The Campus History Series

NORTH CAROLINA
STATE UNIVERSITY

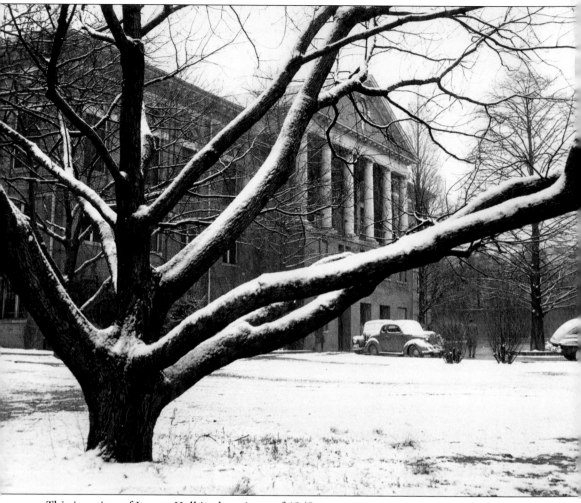

This is a view of Leazar Hall in the winter of 1949.

The Campus History Series

NORTH CAROLINA
STATE UNIVERSITY

LYNN SALSI AND BURKE SALSI JR.

ARCADIA
PUBLISHING

Published by Arcadia Publishing
Charleston, South Carolina

Printed in the United States of America

Library of Congress Catalog Card Number: 2005923389

For all general information contact Arcadia Publishing at:
Telephone 843-853-2070
Fax 843-853-0044
E-mail sales@arcadiapublishing.com
For customer service and orders:
Toll-Free 1-888-313-2665

Visit us on the Internet at www.arcadiapublishing.com

To honor Louie B. Hoffman, North Carolina State University graduate, 1946.
Also for Burke Salsi Sr., Mrs. Ann K. Hunt, and the Brothers of Phi Delta Theta.

North Carolina State University has moved into the 21st century with a new campus that will take the institution into the 22nd century. Yet the school has not forsaken its humble roots and traditions, and it has preserved many of the original turn-of-the-20th-century buildings. (Photograph by Burke Salsi.)

CONTENTS

ACKNOWLEDGMENTS

Thanks to Burke Salsi Sr. for his help with photographs and to Brian Salsi for his help in the library. Louie Hoffman and Glenn Farthing were helpful historians, and their personal photographs add a nostalgic and authentic touch.

The following helped in the acquisition of archival photos and information: Todd Kosmerick, university archivist, North Carolina State University; Robert Burton, project archivist for Visual Collections, North Carolina State University; Keith Longiotti, archivist, University of North Carolina at Chapel Hill; Steve Massengill, archivist, North Carolina Office of Archives and History; reference librarians at the D. H. Hill Library; Chancellor James Oblinger and the Chancellor's Office—North Carolina State University; North Carolina State Athletic Media Relations and Brandon Yopp for the photos of Yow, Rivers, and Hodge; members of Phi Delta Theta Fraternity and Ryan Chamberlain for his fraternity and sorority photographs; and members of Delta Gamma Sorority. Most of the photographs and much of the information were obtained from the North Carolina State University Libraries Special Collection Research Center, part of the North Carolina State University Archives.

We'd like to express gratitude to the many alumni who encouraged this publication and particularly to Dr. Joe Cadell, North Carolina State University; Anne B. Hunt, North Carolina State University; and Ben Hughes, executive director of Development and College Relations, North Carolina State University.

We'd also like to acknowledge our friends and family who champion all of our projects: Charlie Kendall, Barbara Springs, Judy Morton, Andrew Martin, Jay Swygert, Maria Swygert, and Morgan Swygert.

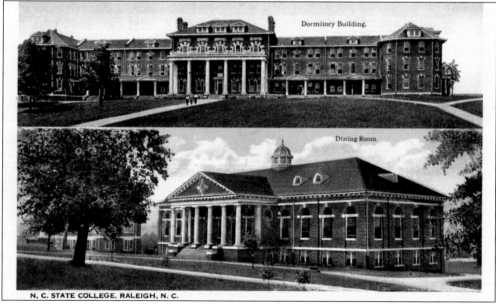

This is a postcard image from the 1920s showing off the modern buildings at State College.

INTRODUCTION

From its beginnings in 1889, North Carolina Agricultural and Mechanics College, now North Carolina State University, has made uphill progress from its initial status as an agriculture and mechanics program designed for the "common man" to its development as one of the top public universities in the country. Its humble beginnings gave State a history of tradition, heritage, dedicated alumni, recognition from major worldwide industries, and a solid record of service to the state and to the nation.

The text represents only a small example of the alumni, students, traditions, and spirit of a place that has expanded from 52 students in 1889 to 29,854 in the span of only 116 years. Lynn and I have attempted to reiterate the importance of the school's contribution in pioneering non-classical education on a college level. North Carolina was one of the first land-grant colleges, and its success inspired other states to follow.

There is much to be said about remembering the people who came first. The Wataugans and individuals like Leonidas Polk, who fought to create something from nothing, are the invisible building blocks that few students and alumni have heard of or will remember. Therefore, this book is as much about the chronicling of history and tradition as it is a report of progress for a job well done.

The vision of administrators in the 1890s, 1920s, 1940s, 1980s, and now in 2005 cemented a future for the university in a fast-moving technological environment. The university's $330 million budget for research-sponsored programs places the institution at the forefront of scientific, technological, public service, and scholastic endeavors.

During the first years of its existence, all of the students were residents of North Carolina. Now students come from almost every state in the nation and 90 foreign countries. In 2005, the university ranked 12th in a national survey of technology transfer strength, which combines the number of patents issued for university research with a comparison of how relevant the discoveries could be to scientists.

State is home to one of the most diverse populations of students in the country. It is much more than an education center; it's home. From its humble beginnings to becoming one of the nation's leading universities, its vision of the future is something that the citizens of North Carolina and the United States can be proud of.

It's a pleasure to be a student at State. It is my privilege to note that the future of North Carolina State University is held in the hands of the leadership of Chancellor James Oblinger, its graduates, and alumni, for students breathe life into the university and then become a part of its history. In return, we take from it what we need for our future, and then, hopefully, we leave State a better place than we found it. For in the end, we're better for having been there.

–Burke A. Salsi Jr.

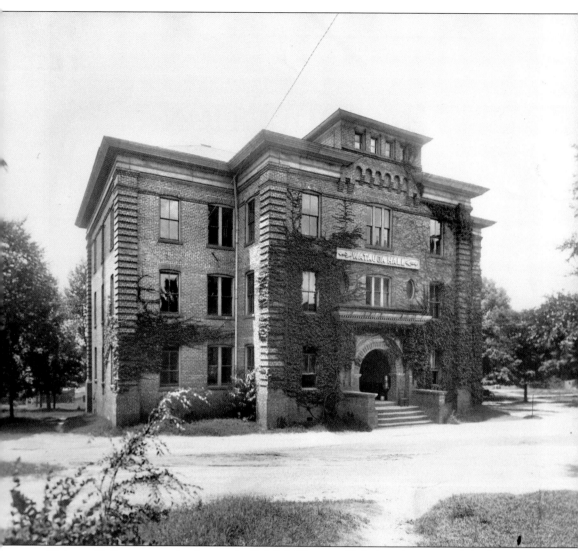

Watauga Hall was named to honor the Raleigh Watauga Club that championed the formation of North Carolina A&M. (Courtesy of North Carolina Office of Archives and History.)

One

A College for the Common Man

Much has been said about the beginnings of the State College for Agriculture and Mechanics. For decades, negative comments and epithets were hard for the students to live with, and there was verbal sparring between the students and alumni of State and the University of North Carolina, which was established 100 years before. It did not take many years for State to find its place in the future of education as well as in the future and progress of the state of North Carolina.

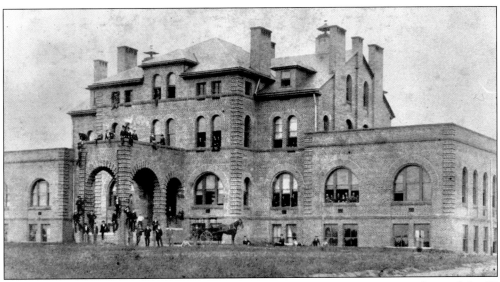

On October 3, 1889, the Main Building was the only structure on campus. It housed the 52 students, as well as a chapel, reading room, dining hall, shop, gym, kitchen, classrooms, and offices. Farmland for agricultural classes lay beyond the building. (Courtesy of North Carolina State University.)

The first freshman class posed on the steps of the Main Building. Some students were as young as 14 years of age. Tuition was $20, and a room was $10 per term. (Courtesy of North Carolina State University.)

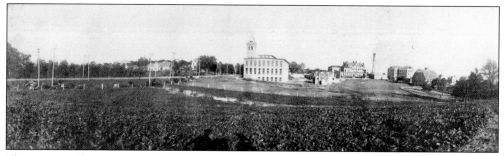

The A&M College campus looked sparse during its early years. This view emphasizes its rural location: a mile from the Raleigh city limits. The campus was primitive. There was no indoor plumbing or electricity, and students studied by kerosene lamps. Outhouses were behind the Main Building. Water was drawn from a well. (Courtesy of North Carolina Office of Archives and History, Brimley Collection.)

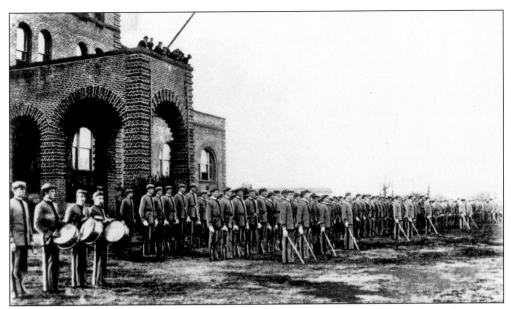

In 1894, military science was added to the curriculum. Students, referred to as cadets, were required to wear uniforms to class. They drilled for three hours per week in front of the Main Building and studied battle formation, cover, firing, and camping. By 1899, cadets marched to and from chapel and to the dining hall. (Courtesy of North Carolina Office of Archives and History.)

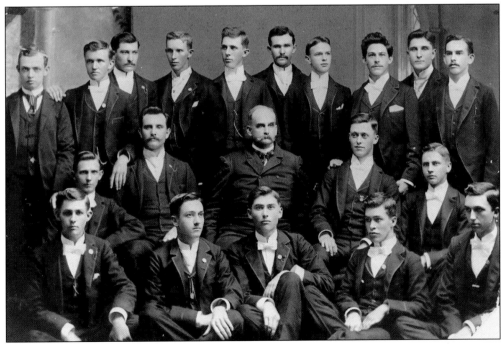

Charles B. Holladay was the first president of A&M. He is pictured at the center surrounded by the first graduating class in 1893. The Main Building was later renamed Holladay Hall in his honor. (Courtesy of North Carolina State University.)

By 1895, dormitories were built near the Main Building to accommodate the increasing student enrollment. The First, Second, Third, and Fourth Dorms were built between 1892 and 1894. (Courtesy of North Carolina Office of Archives and History, from Harpers Weekly Collection.)

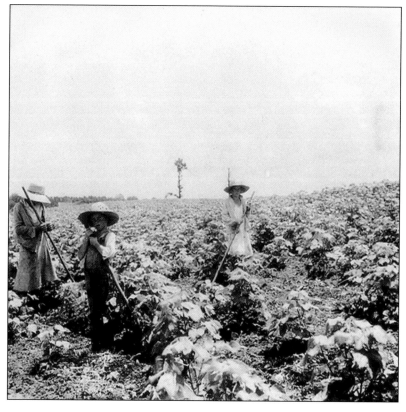

The college was constructed on farmland that was purchased by Stanhope Pullen and then donated. It was a mile and a half from the Raleigh city limits. Agricultural students were required to give manual labor on the farm as part of their education.

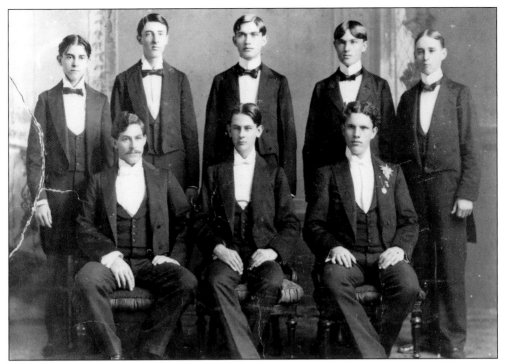

The class of 1898 was small. Due to an economic depression, many students were financially unable to continue their college education. Rather, they had to stay at home and work to help their families. (Courtesy of North Carolina Office of Archives and History.)

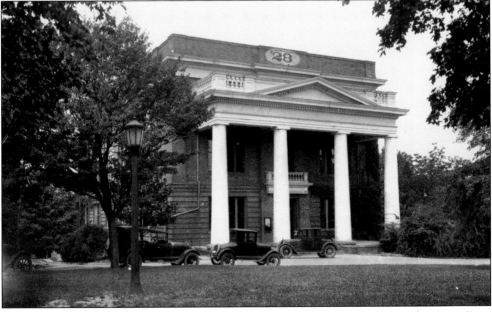

Pullen Hall (1902) was named for R. Stanhope Pullen, who donated the land for the college and for a city park across the road from the Main Building. It was a modern, multi-purpose facility with an 800-seat auditorium, a library of 3,000 books, and a dining hall. (Courtesy of North Carolina Collection, University of North Carolina Library at Chapel Hill.)

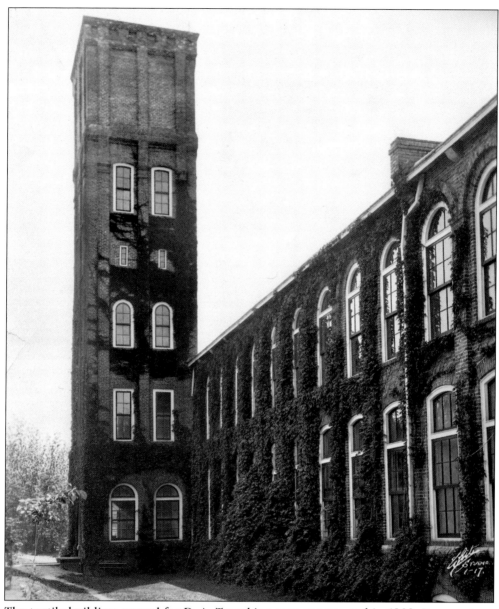

The textile building, named for D. A. Tompkins, was constructed in 1902. It was a two-story brick structure and was equipped with the most modern machines of the day, including looms, carding and spinning machines, and dyeing vats. (Courtesy of North Carolina State University.)

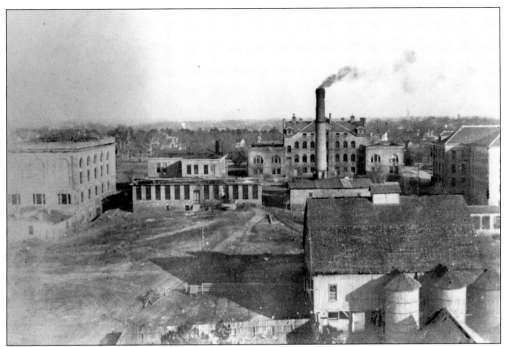

This view of the campus in 1907 shows the addition of buildings and the expansion of the campus property. The new power plant was in service, and the buildings had light and heat. Sewer lines and water lines were extended, and students weren't dependent on well water. (Courtesy of North Carolina State University.)

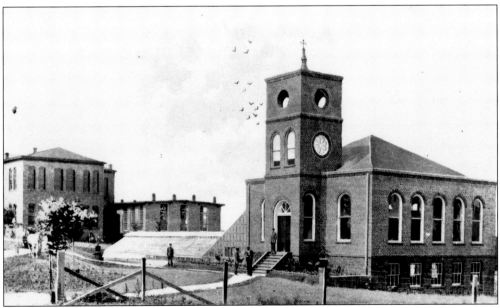

In 1896, Primrose Hall was built for horticulture classes. It later housed the civil engineering classes, a bookstore, ROTC, and geological engineering. (Courtesy of North Carolina Office of Archives and History.)

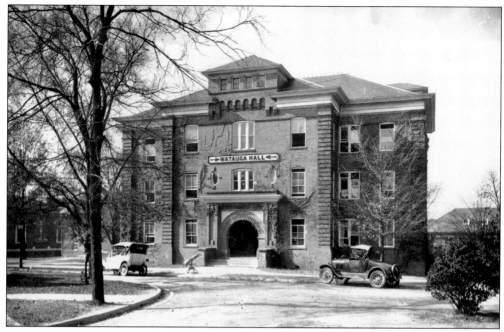

In 1896, Watauga Hall was named for the Watauga Club, which supported the organization of the new college. It was built as a dormitory and dining hall. It was destroyed by fire in 1901 and rebuilt on the same site in 1902. It became the first structure on campus to have central heat, electricity, and indoor bathrooms. (Courtesy of North Carolina State University.)

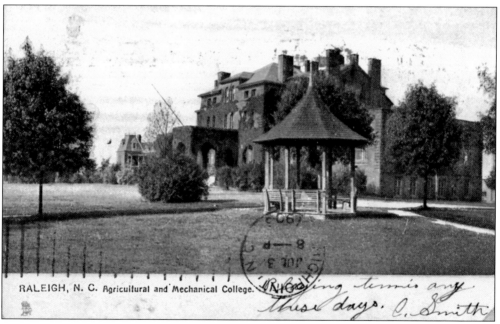

RALEIGH, N. C. Agricultural and Mechanical College.

At the turn of the century, the student population increased, as did the building program and a concern for beautification. The Main Building and gazebo are shown above with a landscaping of plants and trees. The infirmary (far left) was constructed in 1897.

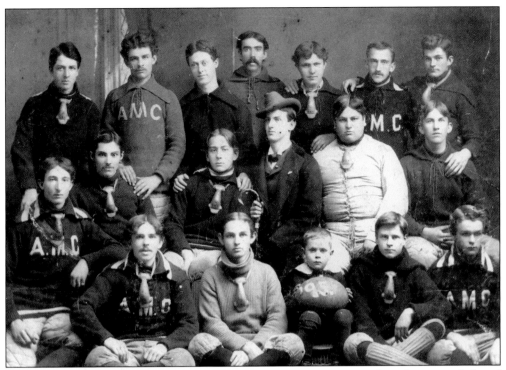

The 1895 football team, pictured here, was known as the Farmers and Mechanics and played few games. The administration frowned on the organization of sports teams and banned out-of-state games until 1897. The field was marked off with a plow, and ditches were dug to mark the goal line. (Courtesy of North Carolina State University.)

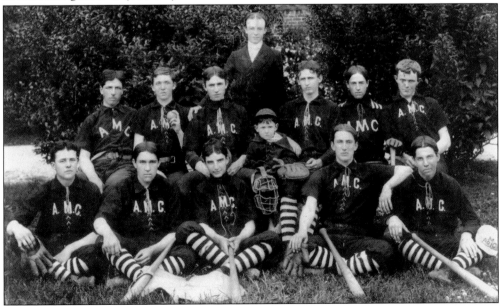

Baseball and football teams were not governed by rules until a coach was hired in 1903. Players were selected by team captains, and the coaches were not associated with the college. The 1899 baseball team is shown above. (Courtesy of North Carolina State University.)

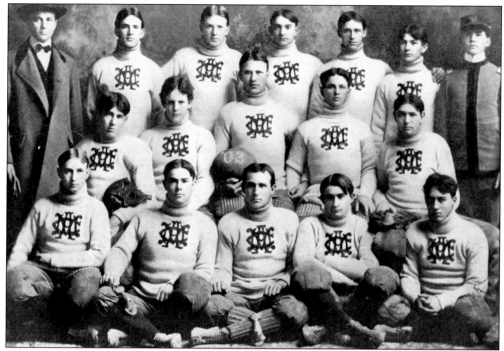

When George Tayloe Winston became president of the college, he accepted the organization of college sports and agreed to pay an athletic director half the salary if the students agreed to pay the other half. The 1902 football team is shown above. (Courtesy of North Carolina State University.)

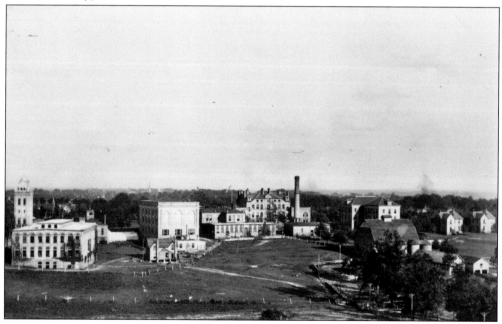

This 1908 view shows the back of the campus. The barn in the right foreground was removed in 1909 and left room for new construction. Another farm was built away from the main campus. (North Carolina State University.)

Two

THE LEAN YEARS

Between 1908 and 1923, the college increased enrollment. D. H. Hill succeeded Winston as president. He served as a professor, bookkeeper, secretary, and vice president. He oversaw the remodeling of buildings and new construction, and he purchased land to enlarge the campus. In 1916, Wallace Carl Riddick, an engineer, became president and brought technical knowledge to his job. He guided the college through World War I and was at the forefront of the development of the Departments of Architecture, Education, Highway Engineering, and Business Administration. In 1917, the college became North Carolina College of Agriculture and Engineering.

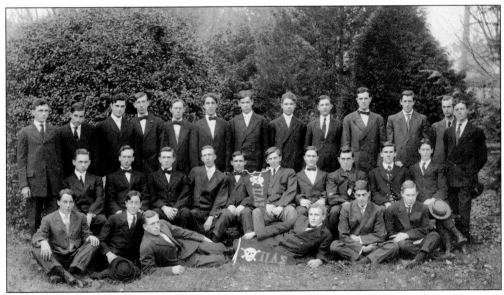

The Pullen Literary Society of 1909 was one of three social organizations dedicated to forensics. These intellectual groups played an important part in student life in the early days and served as an unofficial student government. They opposed the formation of Greek fraternities on campus. (Courtesy of North Carolina State University.)

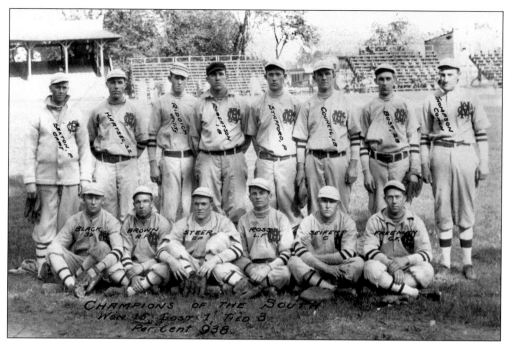

The 1910 baseball team was called the Champions of the South after they won 15 games, tied 3, and lost 1. Frank Thompson (standing far right), a 1909 graduate, served as the coach. (Courtesy of North Carolina State University.)

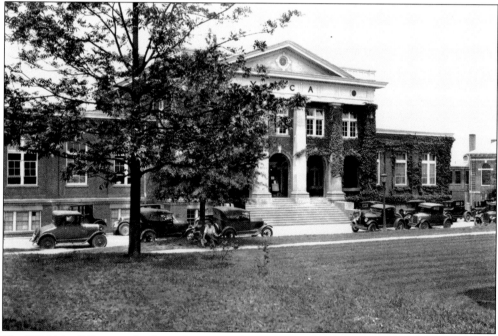

The YMCA building was built in 1913 as a religious center after the freshman class received a grant from John D. Rockefeller. The school's first pool was in the building. In the 1950s, it became the King Religious Center. (Courtesy of North Carolina Collection, University of North Carolina Library at Chapel Hill.)

The Nineteen-Eleven Dormitory opened in 1909 as one of the largest college dormitories in the South. It was named to honor the class of 1911, after the students agreed not to tolerate hazing on campus. (Courtesy of North Carolina Collection, University of North Carolina Library at Chapel Hill.)

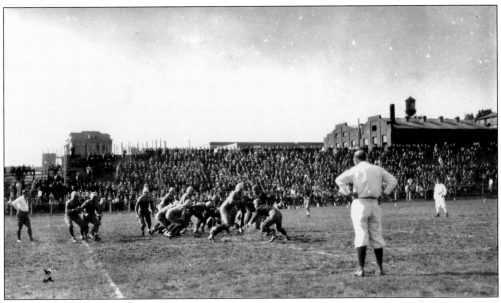

The football team of 1912 was one of the best college teams in the state. Prof. W. C. Riddick was considered be "the father of athletics." The students voted to name the athletic field Riddick Field. The next year, the team won the South Atlantic Championship. (Courtesy of North Carolina Collection, University of North Carolina Library at Chapel Hill.)

Daniel Harvey Hill served the college in many positions. He was president from 1908 to 1916 and was known for his improvements in buildings, equipment, and curriculum. He created the first library for students and was responsible for the tradition of naming campus buildings to honor people who served the college.

Agricultural implements were displayed in front of Patterson Hall in 1915 during an agricultural exposition. The building was constructed on Hillsboro Road across from the entrance to the state fairgrounds. It was named for Samuel Patterson, a commissioner of agriculture. (Courtesy of North Carolina State University.)

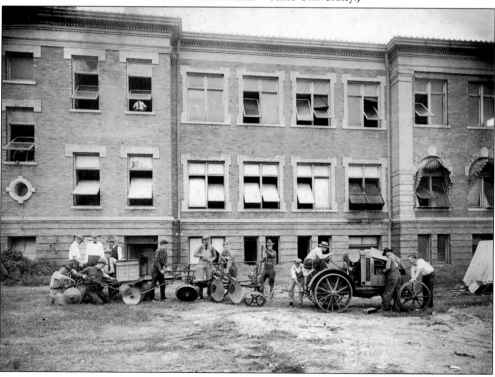

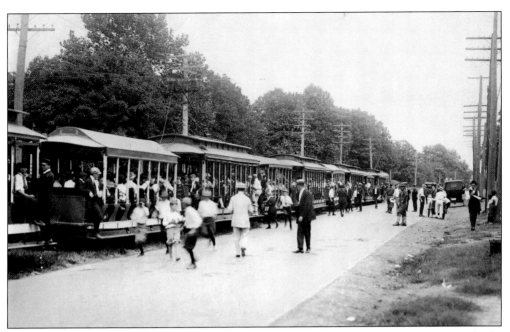

A special trolley was chartered in the summer of 1917 to take 4-H groups on a trip to Raleigh. The trolley line ended at the state fairgrounds entrance in front of Patterson Hall. The trip from town to campus was 5¢. (Courtesy of North Carolina State University.)

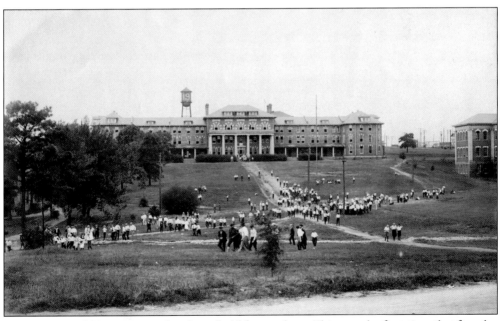

Beginning in 1903, summer school was held for teachers. This was the first time that females were allowed to attend classes, and women generally outnumbered men. Special courses were also held for 4-H and area farmers. Members of the 1917 clubs are pictured above. (Courtesy of North Carolina State University.)

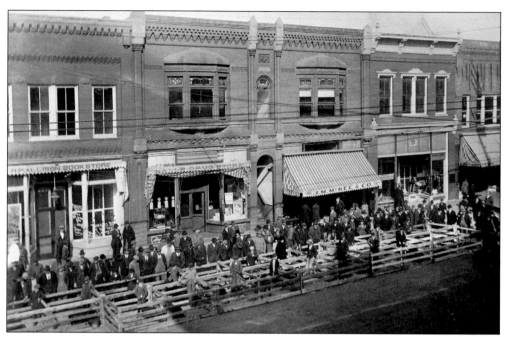

The Pig Club, Poultry Club, Tomato Club, and Corn Club were organized in 1914 to help teach young men how to raise money for their families by selling farm products. The Pig Club exhibited stock in downtown Raleigh in the summer of 1917. (Courtesy of North Carolina State University.)

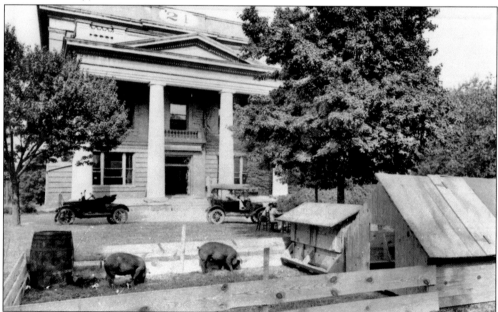

State College's efforts to improve agriculture were boosted through an extension service organized in 1909. The program bridged the gap between the college and rural citizens through educational programs. A swine demonstration was held in 1919 in front of Pullen Hall. These efforts paid off during World War I, when farmers were encouraged to raise more food to help feed the troops. (Courtesy of North Carolina State University.)

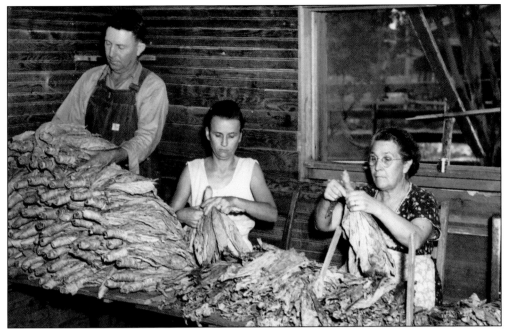

Agricultural education was provided for the entire family through clubs, summer classes, farmers' institutes, and extension services. Cotton and tobacco were big cash crops for families throughout the state. County agents served as a liaison between the college and farmers. The family above is grading tobacco from their harvest. (Courtesy of North Carolina State University.)

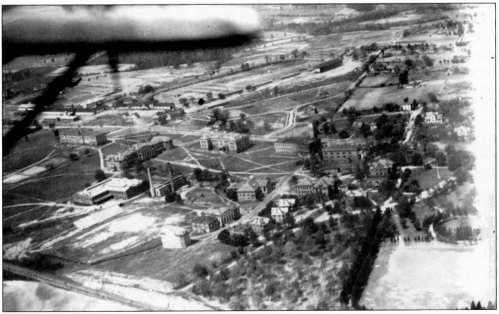

The aerial view from 1919 shows the dramatic progress of the Hill and Riddick administrations. New buildings were constructed to house new programs of agronomy, soils, drainage, animal husbandry, poultry husbandry, and the four-year degree program in textile dyeing. (Courtesy of North Carolina Office of Archives and History.)

Leonidas Polk, North Carolina's first commissioner of agriculture, joined with members of the Watauga Club and campaigned for the establishment of the North Carolina College of Agriculture and Mechanic Arts. He was also the founder of the *Progressive Farmer.*

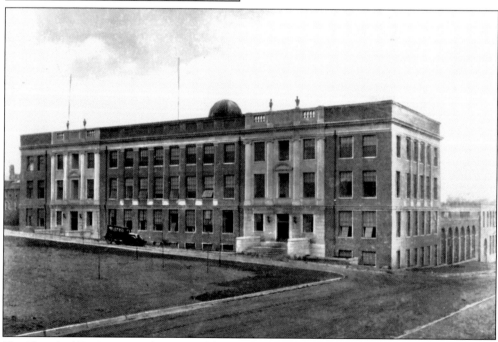

The Electrical Engineering Physics Building was completed in 1926 and later became Daniels Hall. It was constructed behind the buildings that lined the Court of North Carolina and was similar in appearance to the Animal Industry Building that became Polk Hall. (Courtesy of North Carolina Collection, University of North Carolina Library at Chapel Hill.)

The "New Dining Hall" that accommodated 750 students was opened in 1912 on the original location of the cattle pasture. It was named Leazar to honor Augustus Leazar, chairman of the House committee on education when State College was begun. (Courtesy of North Carolina Collection, University of North Carolina Library at Chapel Hill.)

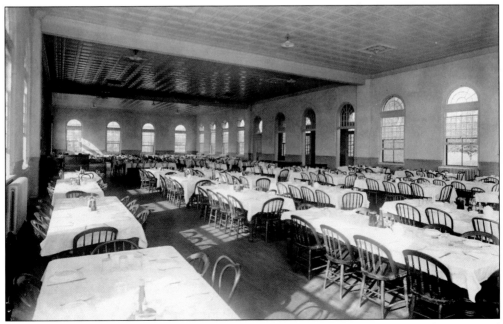

The food served in Leazar was under constant scrutiny. In the 1930s, students staged demonstrations, and the students referred to the facility as "Ptomaine Hall." Dining stopped in 1970, and the building became the School of Design. The university did not open another dining hall until 1984. (Courtesy of North Carolina State University.)

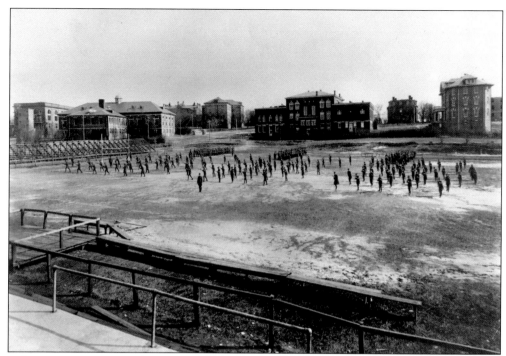

Military training was in full force by 1918. A unit of the Student Army Training Corps was established, the student body was organized into a student corps, and the curriculum became military in content. A bayonet drill was held on Riddick Field to prepare students for military service. (Courtesy of North Carolina State University.)

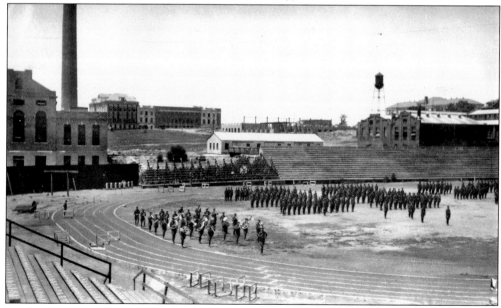

The bugle corps is shown on Riddick Field while cadets were conducting drills. Percy W. Price came to State to join the textile faculty in 1917. He also became the first director of music. In 1917 and 1918, drill was held five afternoons a week instead of three. (Courtesy of North Carolina Collection, University of North Carolina Library at Chapel Hill.)

Camp Polk conducted tank warfare training on the fairgrounds across Hillsboro Road from the campus. By 1918, 7,000 students were soldiers living on the grounds in tents. It was named for the Civil War general from Raleigh, Gen. Leonidas Polk. (Courtesy of North Carolina Office of Archives and History.)

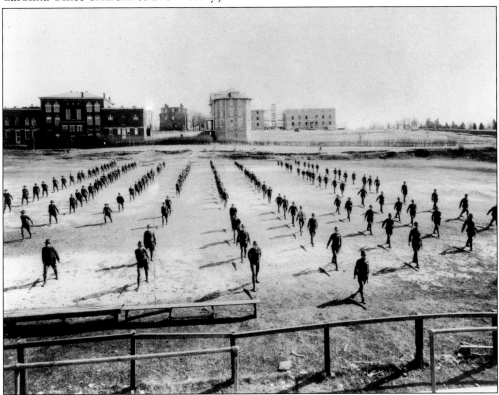

Peacetime drills continued after the war when the ROTC was restored. However, the administration discontinued the rigid discipline of the Student Army Training Corps. (Courtesy of North Carolina State University.)

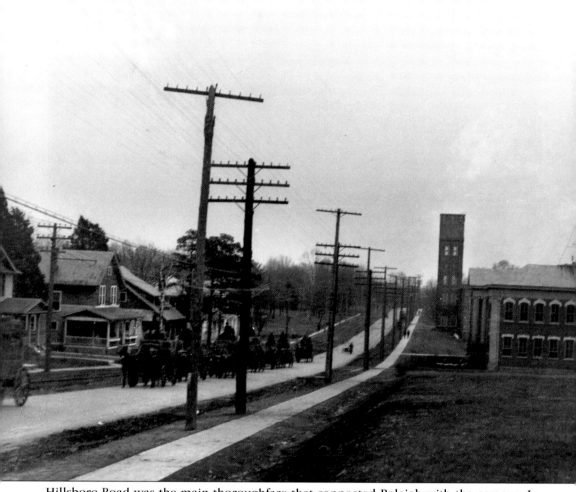

Hillsboro Road was the main thoroughfare that connected Raleigh with the campus. In 1921, houses for professors lined the road. Electrical poles contrast with the mule teams that pulled wagons loaded with produce and cotton to market. (Courtesy of North Carolina State University.)

Three

A TIME FOR REFLECTION

The semi-centennial year of 1939 was a time to reflect on the progress that the college made within the first 50-year period. The years between 1929 and 1940 were years of struggle thanks to the Great Depression and the reduction of state appropriations. Between 1931 and 1934, enrollment declined and professors received a pay cut. Every program was cut and building projects were cancelled. In 1931, the state-supported universities were consolidated and joined under one system. State College had to fight to remain open, as a special commission suggested that the school be reduced to junior college status and that all advanced programs be held at the University of North Carolina. Governor Gardner dropped the plan, and the college survived.

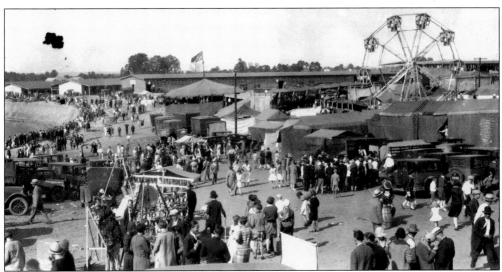

It's no accident that the college was located across the road from the state fairgrounds. The fair moved to Hillsboro Road in 1873 and operated under the auspices of the State Agriculture Department. Students prepared exhibits and demonstrated modern techniques. In 1895, the main attraction was chicken incubators. In 1928, the fair moved to a larger site about a mile from campus. (Courtesy of North Carolina Collection, University of North Carolina Library at Chapel Hill.)

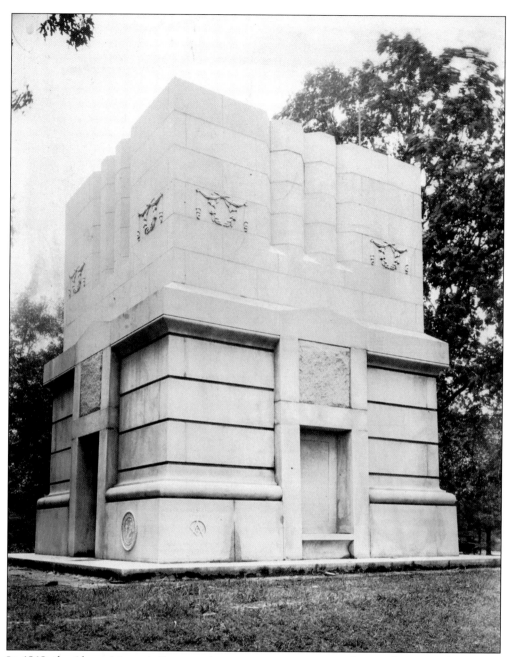

In 1919, the Alumni Association voted to erect a monument to honor the 33 students who died in World War I. They were unable to raise the funds needed to construct the entire bell tower. The first section of the Memorial Tower was completed in January 1922. (Courtesy of North Carolina State University.)

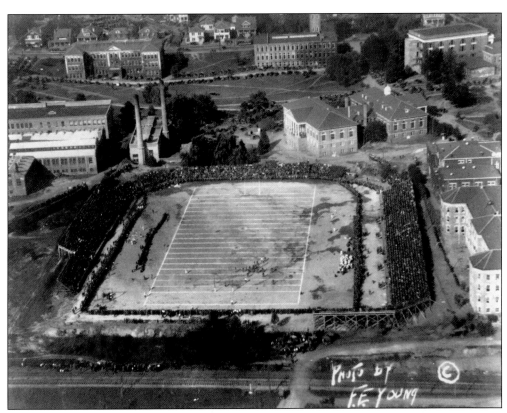

In the 1920s, the State-Carolina game became a Fair Week tradition. In 1923, 13,000 people crowded into Riddick Stadium to witness the annual event. Unfortunately, State lost by two touchdowns. (Courtesy of North Carolina State University.)

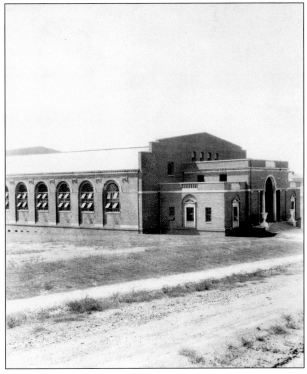

The Frank Thompson Gymnasium was opened in 1925. It honored the man who had been a student, athlete, and coach before Thompson lost his life in World War I. The gymnasium was considered "An Ideal of Physical Education" and had seating for 2,500 spectators. It also served as the central registration location for class enrollment at the beginning of each term. (Courtesy of North Carolina State University.)

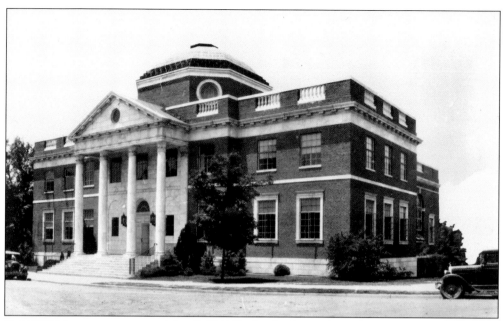

D. H. Hill Library was a memorial to D. H. Hill, the third president of the college. Completed in 1926, it was designed by Hobart Upjohn to resemble Monticello. By 1932, it housed over 30,000 volumes and was a federal depository. (Courtesy of North Carolina State University.)

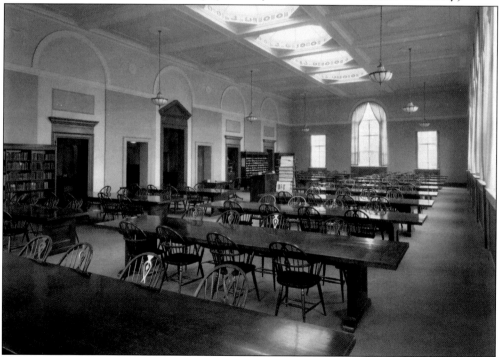

D. H. Hill was a modern library with a reading room (shown above) and a reference room. By the 1950s, there was a need for a new facility. The building was renovated, and in 1955, the building was renamed Brooks Hall in memory of former president Eugene Clyde Brooks and was used by the School of Design. (Courtesy of North Carolina State University.)

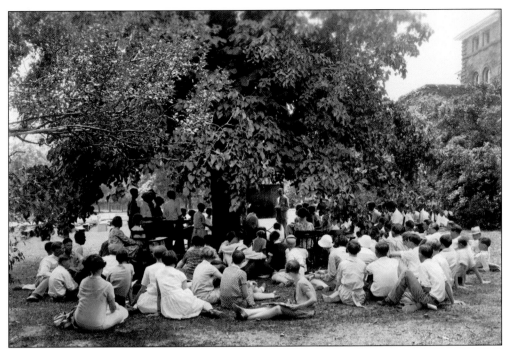

John Bradford's first rural summer school short course classes were held in 1927. He was vice director of short courses in agriculture. He promoted the courses and was successful in having farmers come from all over the state to attend. (Courtesy of North Carolina State University.)

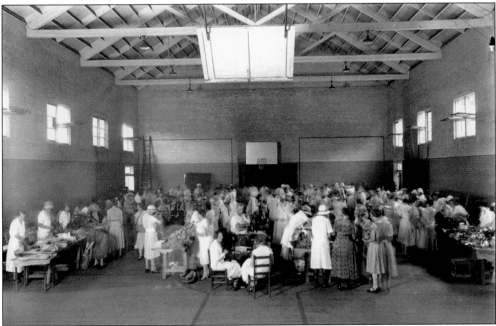

Short courses helped rural women learn more about home economics. Classes were held to teach the handling of produce and safe canning. The Agriculture Department and the Extension Service assisted with farmers markets. (Courtesy of North Carolina State University.)

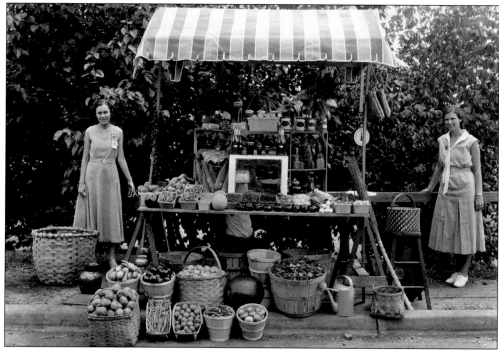

In 1932, farm families were assisted in the development of curb markets to help generate more income from produce. It was a feature of a summer course and was designed to also help farmers calculate their production. The model curb market above was a demonstration developed by the School of Agriculture and the Extension Service. (Courtesy of North Carolina State University.)

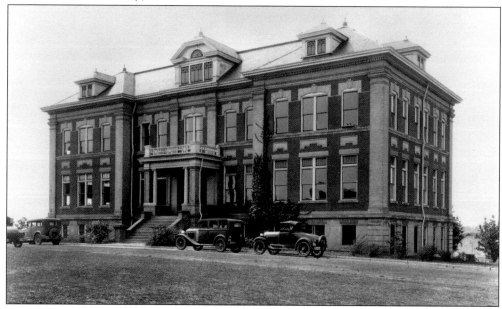

The zoology building, constructed in 1912, was first known as the Animal Industry Building. It was located on "Ag Hill" and housed poultry, entomology, and zoology. (Courtesy of North Carolina Office of Archives and History.)

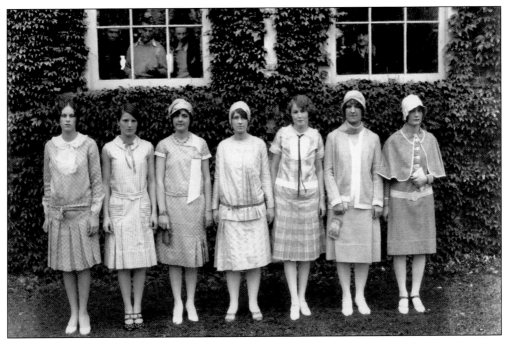

Between 1927 and 1943, style shows were presented during the textile expositions. Winners of the 1929 show are shown in front of Tompkins Hall. The show promoted the use of cotton and rayon fabrics that were designed and produced by textile students. Home economic majors from Meredith, Peace, and St. Mary's Colleges created and modeled the finished garments. (Courtesy of North Carolina State University.)

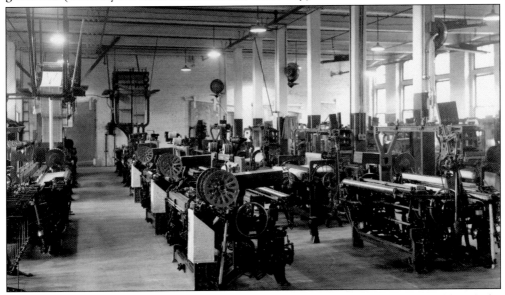

The weave room was located on the first floor of Tompkins Hall. It was equipped with the standard belt-driven dobby looms and Jacquard looms that could be programmed to weave complicated patterns. Pictures of the governors of the Southern states were woven on the machine and handed out as souvenirs at the textile exhibitions. (Courtesy of North Carolina State University.)

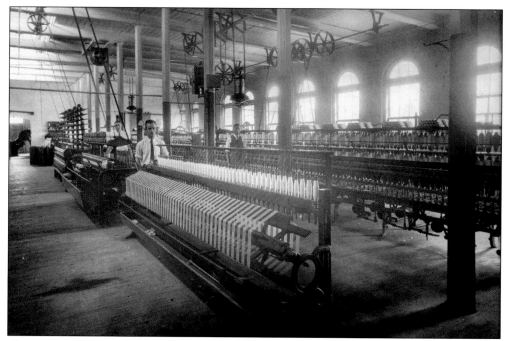

Above is a view of skein winding machinery. The introduction of synthetic fibers increased the demand for textile graduates. The increased number of students and the need for more research space led to a Public Works Administration grant for the construction of a new building for the School of Textiles. (Courtesy of North Carolina State University.)

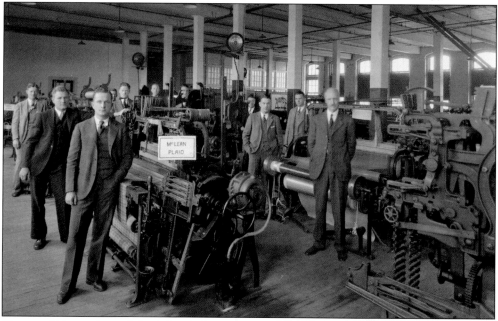

Thomas Nelson, dean of the School of Textiles, is shown above with his students. He served for 48 years as a member of the textile faculty and was the first dean of the textile school. The Tompkins building was renovated and used for mathematics and education. (Courtesy of North Carolina State University.)

O. Max Gardner was a 1903 graduate of State. He was captain of the football team and was the first graduate of State to be elected governor of North Carolina. During the Depression, he championed agricultural programs, which gave a boost to the school and helped farmers. (Courtesy of North Carolina State University.)

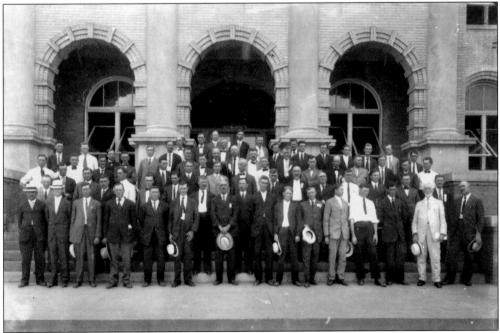

The agriculture class of 1935 is posed in front of Patterson Hall. As students of Ira Schaub, many would become extension agents and act as liaisons between the agriculture school and North Carolina farmers. (Courtesy of North Carolina Office of Archives and History.)

Pipes and Drums (*c*. 1930) were a part of the ROTC program. In later years, they wore the standard uniforms. (Courtesy of North Carolina Office of Archives and History.)

The president's house was completed on Hillsboro Road in 1930, during Eugene Clyde Brooks's tenure. It was constructed near the main campus on a plot of land that had been neglected. It continues to serve as the chancellor's residence and as a location for university social functions. (Photograph by Burke Salsi.)

In the 1920s, the football team was referred to as the Wolfpack. Other teams were known as the "Red and Whites," but in 1946, Chancellor John William Harrelson called for a new name since German submarines were known as "wolfpacks." Students prevailed and all teams became part of the Wolfpack in 1947. (Courtesy of North Carolina State University.)

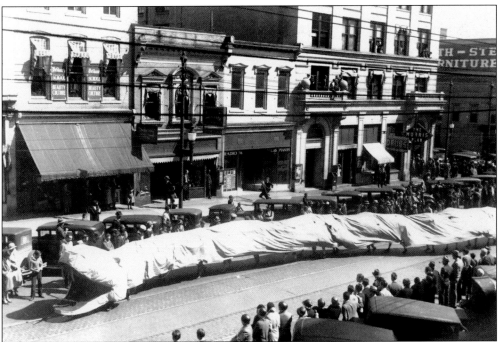

St. Patrick was honored as the patron saint of engineering. He drove the snakes out of Ireland, and he invented the first worm dive. The St. Patrick's Brawl was the best-known social event during the Engineers' Fair. In 1930, students constructed a 200-foot worm for a parade in Raleigh. (Courtesy of North Carolina State University.)

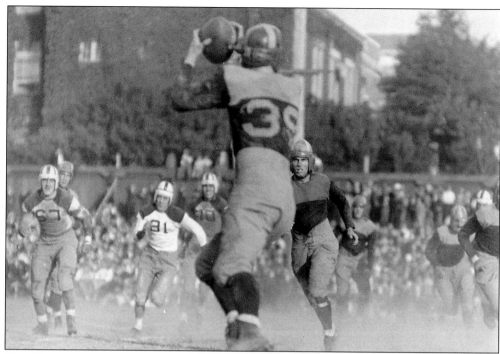

The Clemson receiver is being pursued by a State player in the 1932 game, which State won 13-0. Not pictured is when Ray Rex, a State player, set a national record by running 102 yards for a touchdown. (Courtesy of North Carolina State University.)

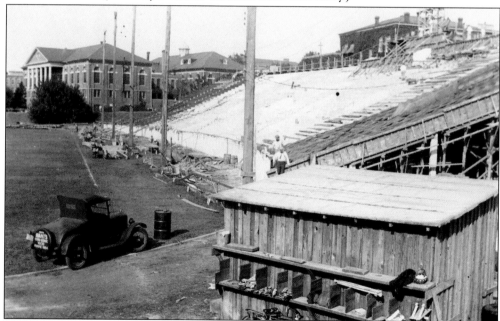

Riddick Stadium was finally completed in 1933 with lighting and the addition of concrete bleachers on the east side. The field house was constructed with the help of the Alumni Association and a grant from the Works Progress Administration. (Courtesy of North Carolina State University.)

Col. John William Harrelson was a graduate of the class of 1909. In 1934, he was the first alumnus to be selected as the dean of administration (now chancellor). He was head of the department of mathematics and was in active service in both world wars. He was always known as "Colonel."

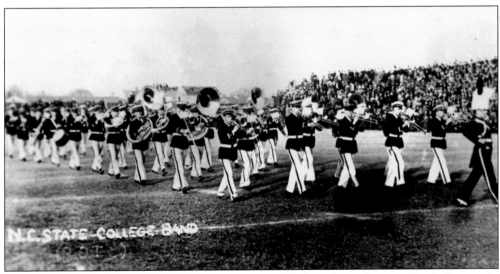

The North Carolina Marching Band performs at Riddick Stadium during a football game in 1934. The Department of Music was under the direction of Maj. P. W. ("Daddy") Price, and the band, concert band, and orchestra contributed a great deal to the campus cultural life. (Courtesy of North Carolina Office of Archives and History.)

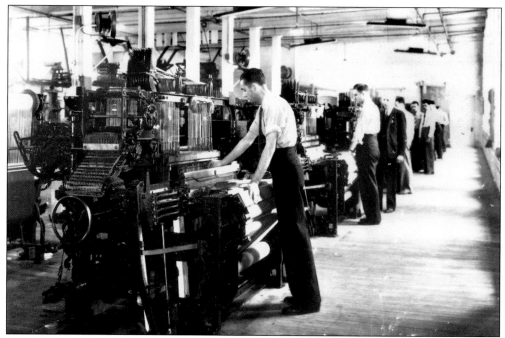

Prior to World War II, the textile school was criticized for not focusing on research. Critics claimed that Dean Nelson was running the department like a trade school rather than like a college. There was great demand in 1938 for mill managers and skilled textile scientists. (Courtesy of North Carolina Office of Archives.)

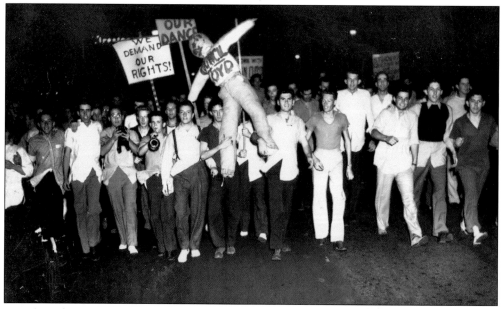

On advice from Dean Edward Cloyd, the Faculty Council cancelled the annual Finals Dance because it was to be held on a Monday night and it might disturb neighbors. The decision was made in February, but the students weren't notified until April. There was no time to reschedule; on April 27, 1938, 400 students protested by marching to Capitol Square and burning Dean Cloyd in effigy. (Courtesy of North Carolina Office of Archives and History.)

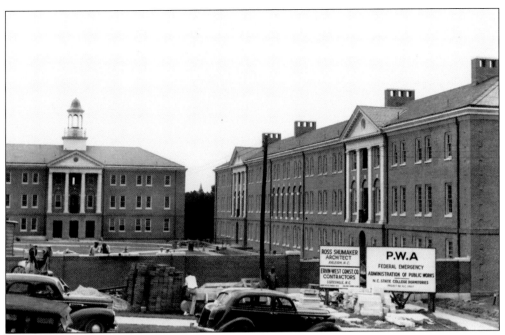

The Eighth Dormitory (right) and the Ninth Dormitory (left) are shown under construction. They were among the five new dorms built with Works Progress Administration grants in 1939 and 1940. The Tenth Dormitory was built behind the Ninth. (Courtesy of North Carolina Office of Archives and History.)

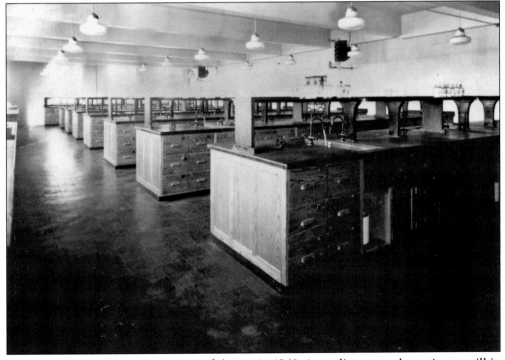

The chemistry laboratory was state of the art in 1940. According to students, it was still in use in 2005. (Courtesy of North Carolina Office of Archives and History.)

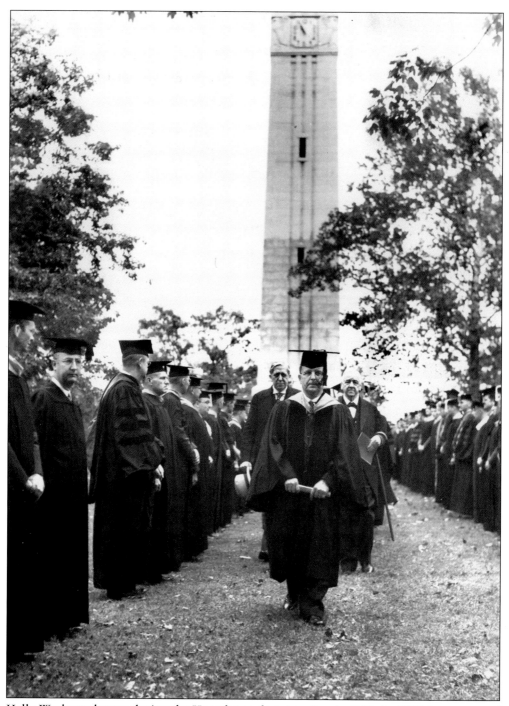

Hello Week was begun during the Harrelson administration in 1935. In 1939, it was part of the 50th anniversary celebration. Harrelson and the faculty are shown at the Memorial Bell Tower, which was still incomplete. The stonework was finished in 1937, but it didn't have bells. (Courtesy of North Carolina Office of Archives and History.)

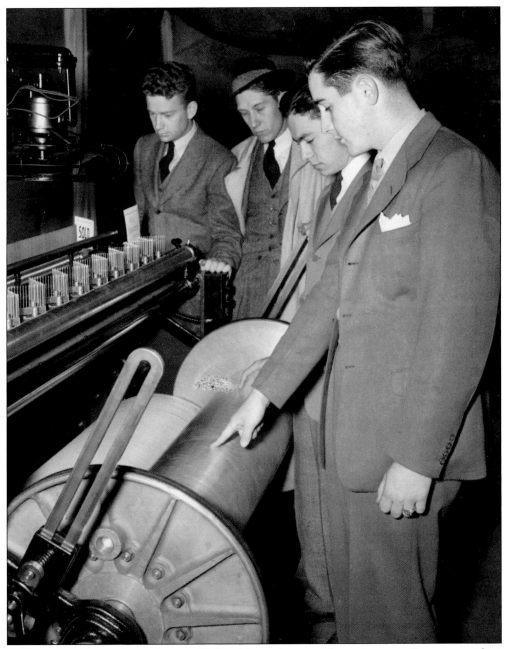

William C. Friday is shown here in 1940 with modern textile equipment. He was president of the class of 1941. In May 1957, Friday became president of the Consolidated University of North Carolina. (Courtesy of North Carolina State University.)

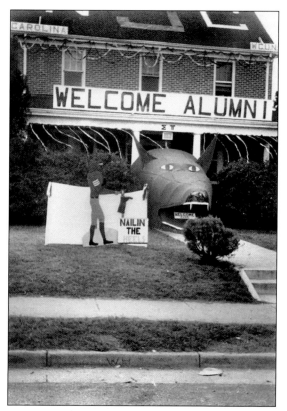

A giant wolf was constructed to welcome homecoming guests to the Sigma Pi Epsilon fraternity house in 1941. Louie Hoffman and his "brothers" hoped that the Wolfpack would "Nail the Heels." (Courtesy of Louis B. Hoffman private collection.)

Sigma Pi Epsilon fraternity was among the first social organizations on campus. Other early Greeks were Kappa Alpha, Kappa Sigma, Sigma Nu, Phi Kappa Alpha, Delta Sigma Phi, and Alpha Zeta. Sigma Pi Epsilon members are shown below in 1941, less than a year before the declaration of World War II. (Courtesy of Louis B. Hoffman private collection.)

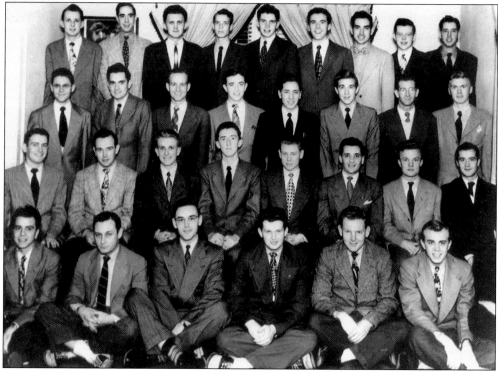

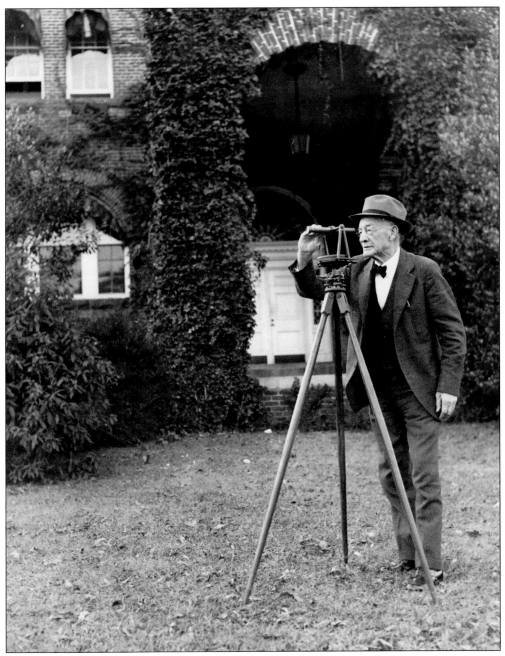

In 1940, Pres. Emeritus W. C. Riddick posed with the surveying equipment that was used in the 1830s to lay out the right-of-way for the Raleigh and Gaston Railroad. Riddick, a 1903 graduate, took his first lessons in surveying on this instrument. (Courtesy of North Carolina State University.)

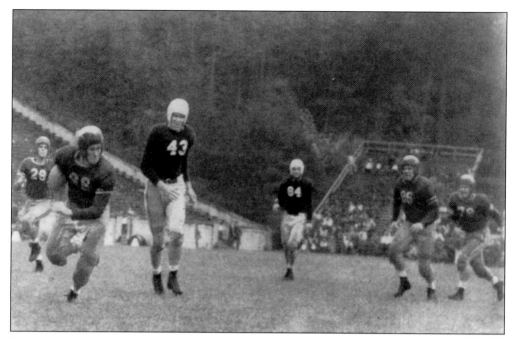

Bob Cathey is shown running for the winning touchdown on November 1, 1941, when State won 13-7 over the University of North Carolina at Chapel Hill. Carolina has remained State's biggest rival in sports. (Courtesy of North Carolina State University.)

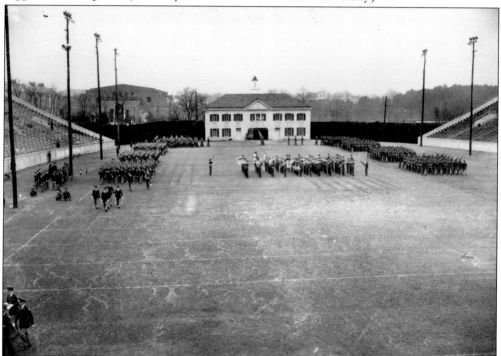

ROTC dress parades, like the one above in Riddick Stadium, were a part of every official function at State. These presentations always included the Regimental Band. (Courtesy of North Carolina Office of Archives and History.)

50

Social and service fraternities have always helped local families through drives, fund-raising, and special events. At Christmas in 1940, the Phi Omega fraternity organized a toy drive and distributed the gifts to needy children. (Courtesy of North Carolina Office of Archives and History.)

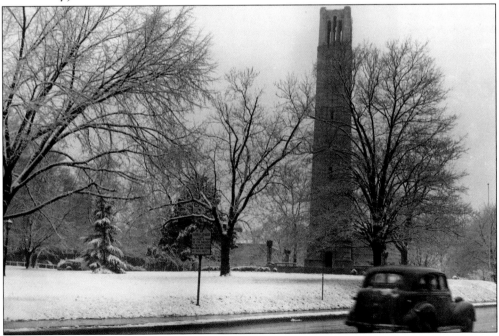

The Memorial Bell Tower became the most important gathering place on campus after its construction. The tower, constructed on Hillsborough Street, is shown above in a snowy setting during 1940. (Courtesy of North Carolina State University.)

In order to expand, the college took advantage of the land "on the other side of the tracks." Therefore, the new dormitories were separated from the classroom buildings by a railroad track. Even though a bridge was constructed on Pullen Road in 1925, the tracks remained a danger for students taking shortcuts. In the 1930s, student pranksters soaped the tracks, hoping to stall an engine. When one did, a second locomotive came from Raleigh to give it a push. (Courtesy of North Carolina State University.)

Four

THE WAR YEARS

During World War II, State College was more like an army training facility than it was a college. All extracurricular activities and clubs were cancelled, and the college had an influx of military personnel participating in short training courses. Much of the student body was activated because all students were members of the ROTC. Enrollment in four-year programs was reduced, and many members of the faculty and administration, who were members of the reserves, were activated. The dominating conversation in Raleigh was about war. Glenn Farthing recalled being called upon to work with a group of students at St. Mary's (at the request of their president) to help them understand the involvement that the ROTC had with the war effort.

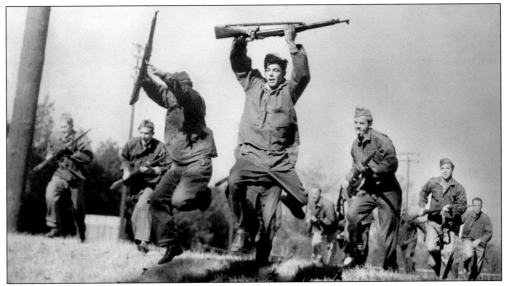

Between 1942 and 1945, the ROTC dominated the curriculum and the campus. Military training was intensified, and the Alexander and Turlington Dormitories were part of a barracks area that was fenced off from the rest of the campus. Students used open fields around the college and wooded areas off of Pullen Road for exercises. (Courtesy of North Carolina State University.)

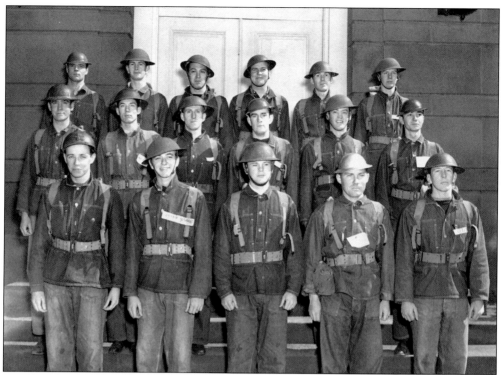

Scabbard and Blade was the society for the most outstanding ROTC students. The 1942 inductees are pictured above. (Courtesy of North Carolina Office of Archives and History.)

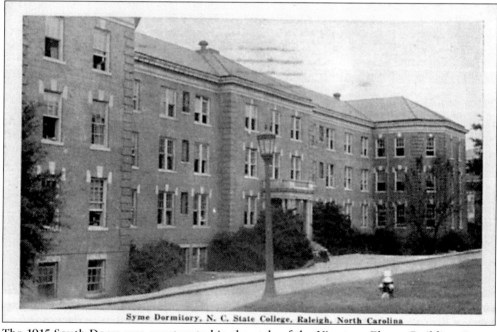

Syme Dormitory, N. C. State College, Raleigh, North Carolina

The 1915 South Dorm was constructed in the style of the Nineteen-Eleven Building. It was enlarged in 1924 and renamed to honor George F. Syme, class of 1898, a highway engineer. (Courtesy of North Carolina Office of Archives and History.)

Glenn Farthing (left) entered State in 1939 and received a degree in engineering in 1943. He was shipped to Europe where he saw action at the Battle of the Bulge. Louis Hoffman spent his first two years at State running to class in uniform. After two years, his ROTC class was activated. He saw action in Europe, and after the war, he returned to complete his engineering degree. (Courtesy of Farthing and Hoffman.)

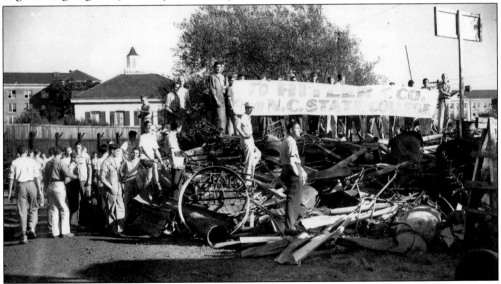

The campus scrap drive netted three carloads of metal (150,000 pounds) for the war effort in three hours. The *Technician* announced that it was "the greatest project ever undertaken by State College men." An old, Spanish-American War cannon was the first object to go on the heap. (Courtesy of North Carolina Office of Archives and History.)

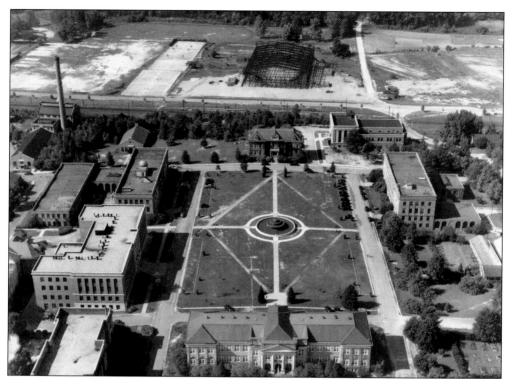

Above is an aerial view of the Diesel Engineering Laboratory. The Navy Diesel Engineering program was established during World War II. The program was developed to train officers in the operation of diesel engines. They were used in submarines, destroyers, and other naval vessels. The laboratory building housed the engines. (Courtesy of North Carolina State University.)

The fountain served as the cooling system for the engines in the Diesel Engineering Laboratory by operating while the engines were running. After the war, the fountain was shut down; however, it was not demolished until the 1960s. The fountain was only activated during the Engineers' Fair. (Courtesy of North Carolina State University.)

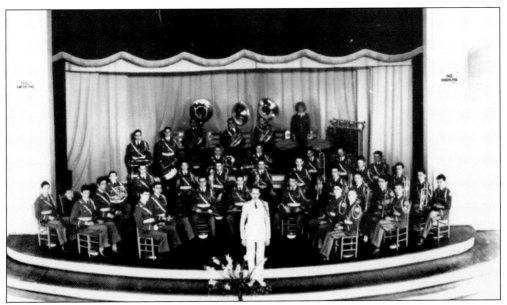

Maj. C. D. Kutschinski is shown in front of the concert band on February 25, 1945. He was also the director of the drum and bugle corps, the orchestra, and the marching band. (Courtesy of North Carolina Office of Archives and History.)

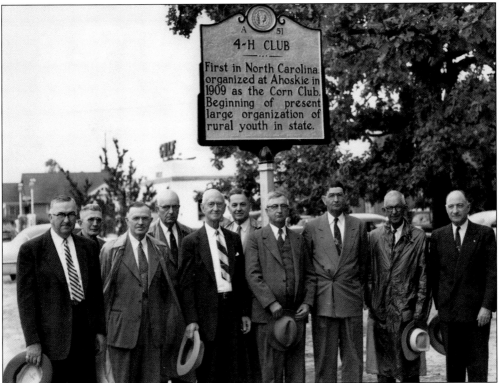

After the war, the extension division of the college began anew with programs for farmers and their families. Technology was rapidly improving, and with it came new methods and machinery. (Courtesy of North Carolina State University.)

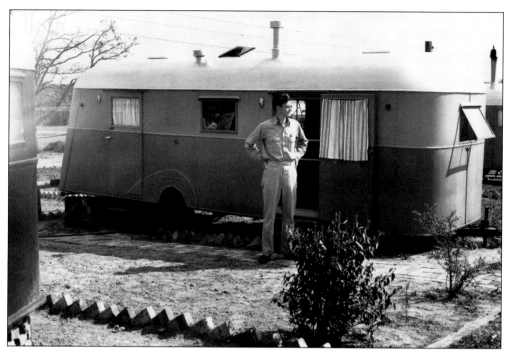

After World War II, trailers were brought in to provide housing for married students. Small communities were formed and were known as Vetville, Westhaven, and Trailwood. Married veterans received $75 per month to help with living expenses. (Courtesy of North Carolina State University.)

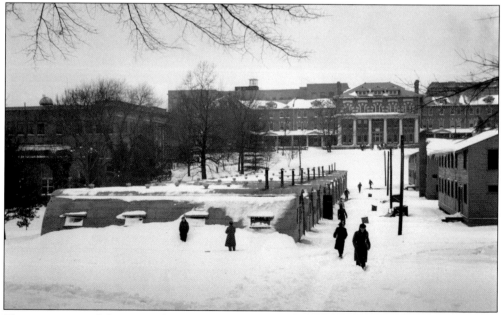

There was a need for more classrooms as well as living quarters for the postwar student population. Compared to pre-war enrollments, the number of students nearly doubled. Above is a view of the main campus in the winter of 1948. (Courtesy of North Carolina State University.)

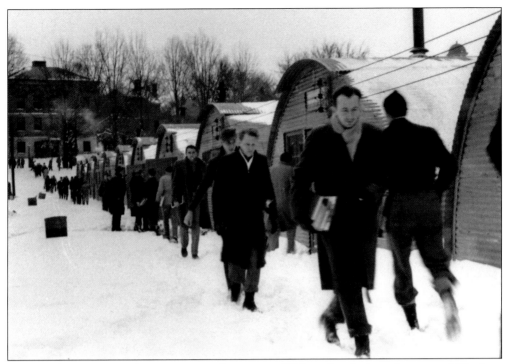

Quonset huts were used as temporary classrooms. With no insulation, they were difficult to heat and were crowded with 40 desks. Students seated next to the curved walls were required to lean over throughout the classes. (Courtesy of North Carolina State University.)

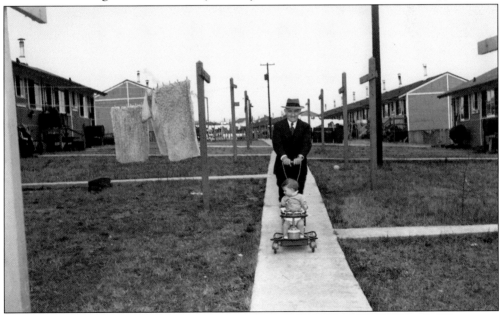

Frank P. Graham, the Consolidated University president, pushes a stroller while visiting Vetville in 1947. The village for veterans was located on the site of Bragaw Dorm. In March 1949, he was appointed to fill an unexpired U.S. Senate term, and Gordon Gray became the new president. (Courtesy of North Carolina State University.)

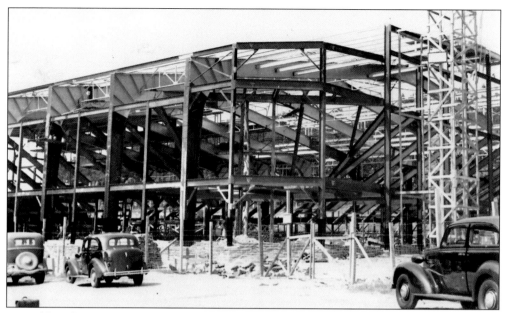

Reynolds Coliseum was originally proposed in the 1930s. Even though the Depression caused the plans to be shelved, money was raised to purchase the necessary steel. It lay on the ground until a donor paid to have it raised during World War II. The framework stood until 1948, when the construction continued. (Courtesy of North Carolina Archives and History.)

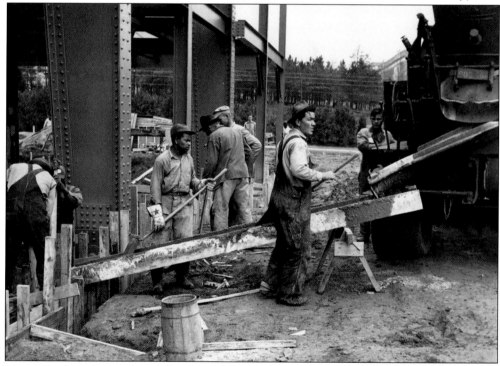

The coliseum construction took more than a year. The building was designed to seat 10,000 fans; however, basketball had become so popular that an additional 2,500 seats were added. Workers are shown above pouring concrete. (Courtesy of North Carolina State University.)

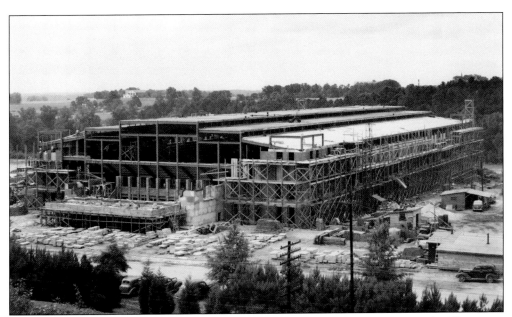

This long shot of Reynolds Coliseum shows the massive structure early in 1949. There was room for dressing rooms and an ice-skating rink. Due to the high operating costs, the building was maintained through outside rentals. However, there were complaints that many events disrupted campus life. (Courtesy of North Carolina State University.)

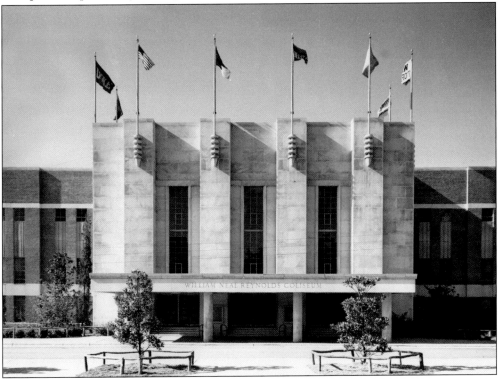

Reynolds Coliseum was a campus landmark for years. When completed, it was a plus for State's image. (Courtesy of North Carolina State University.)

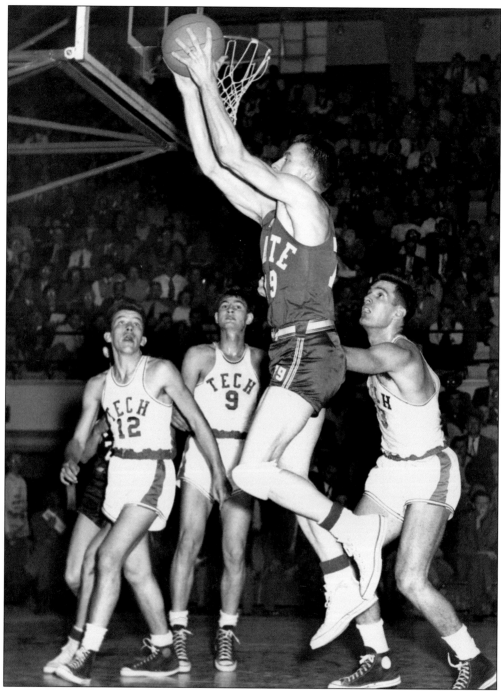

Coach Everett Case brought a great deal of excitement to the basketball program when he arrived in 1946. The completion of Reynolds Coliseum was a boon to the students and to the athletic programs. The first basketball game was played on December 2, 1949, when State won 67-47 over Washington and Lee. (Courtesy of North Carolina State University.)

The "Red Terrors" gained power under Coach Case and swept the Southern Conference in 1947. Pictured at right are, from left to right, Jack McComas, Dick Dickey (All-American), Warren Cartier, and Coach Everett Case in 1948. (Courtesy of North Carolina State University.)

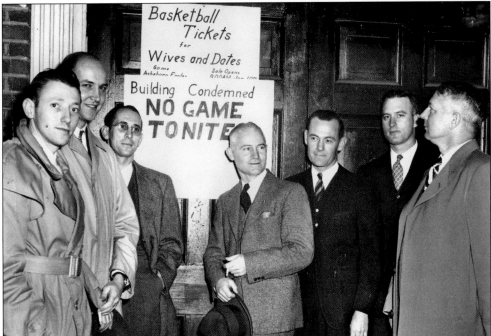

After the war, interest in sports exploded. Thompson was obsolete, and the fire marshal allowed only 1,200 seats to be sold. In 1947, fans determined to see the Carolina game broke through the doors and entered by climbing through the windows. The game was cancelled. Fearing a repetition, the next game was cancelled at the last minute. Ticket holders found this sign at the entrance. (Courtesy of North Carolina State University.)

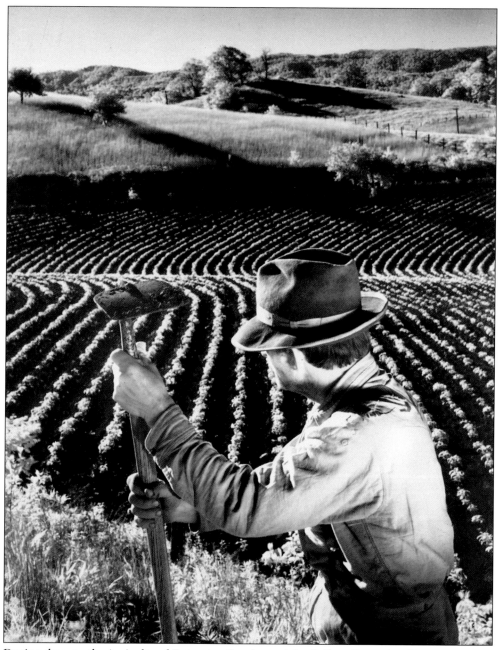

During the war, the Agricultural Extension Service and the College Extension Division grew in importance, and agents covered the farms of rural North Carolina. By 1945, farms set records in growing potatoes, corn, and cotton. (Courtesy of North Carolina State University.)

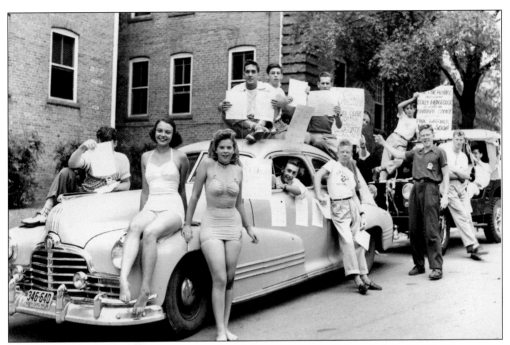

During the war, clubs, fraternities, and social events were disbanded. In 1947, things were back to normal, and the campus was filled with the excitement of exhibitions, parades, socials, and the establishment of service and social fraternities. The 4-H Club staged a political rally and parade in 1949. (Courtesy of North Carolina State University.)

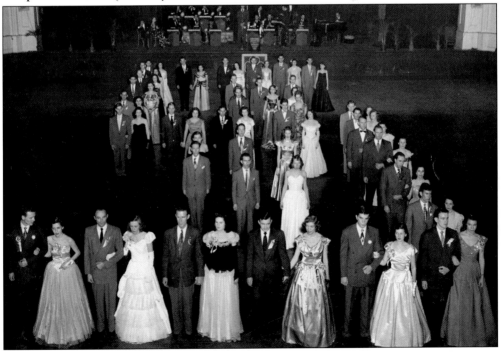

In 1948, the Engineer's Society re-established its annual dance. The photograph above was taken at the 1949 Spring Ball. (Courtesy of North Carolina State University.)

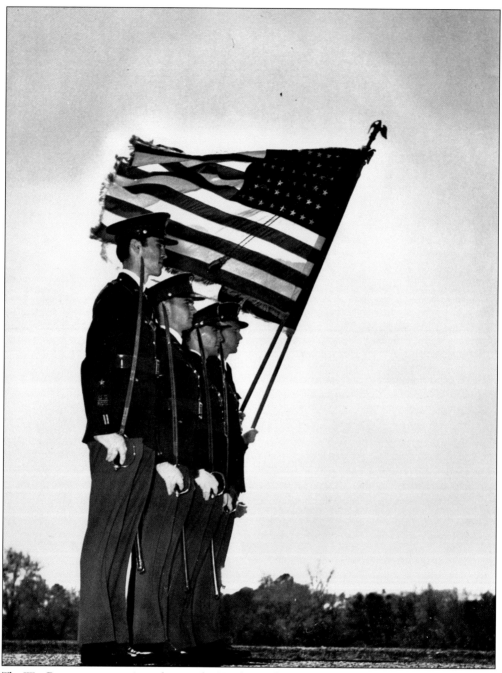

The War Department consistently gave the North Carolina State ROTC Color Guard an "Excellent" rating. The photograph was taken in 1949. (Courtesy of North Carolina State University.)

Five

A NEW ERA

A new era began at the end of World War II. Programs were revised and improved. The war left the campus in need of new buildings and living quarters to accommodate new students and veterans taking advantage of the GI Bill. Engineering was the most popular major, and the program underwent radical changes. The modernization of facilities led to the expansion of research in many different departments. Contract research was introduced. Specific projects included research for disease and pest-resistant crops and the invention of a mechanized harvester for tobacco crops.

Efforts were made to complete the Memorial Bell Tower. Construction began in 1929 and continued piece-meal as funds were raised. The Alumni Association raised the money to purchase the clock works, clock numerals, and the bells. (Photograph by Burke Salsi.)

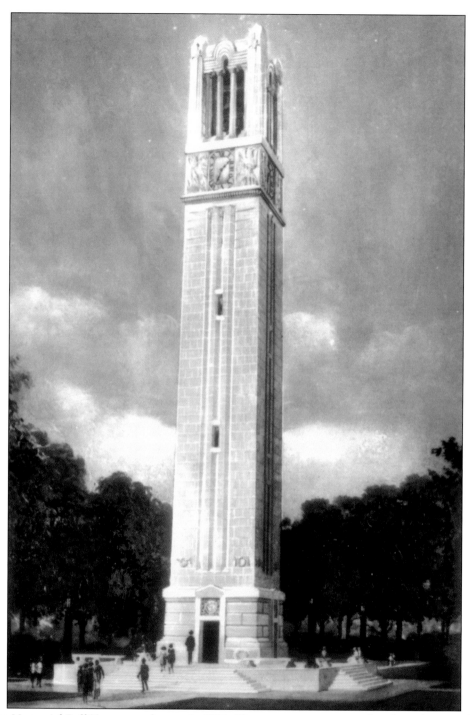

The Memorial Bell Tower was begun in 1921. The structure was completed in 1937, yet the memorial was not completed until the Alumni Association raised the funds for the shrine room, the bronze door, and the carillon. Gov. R. Gregg Cherry presented the dedication address on November 11, 1949. (Courtesy of North Carolina Collection, University of North Carolina Library at Chapel Hill.)

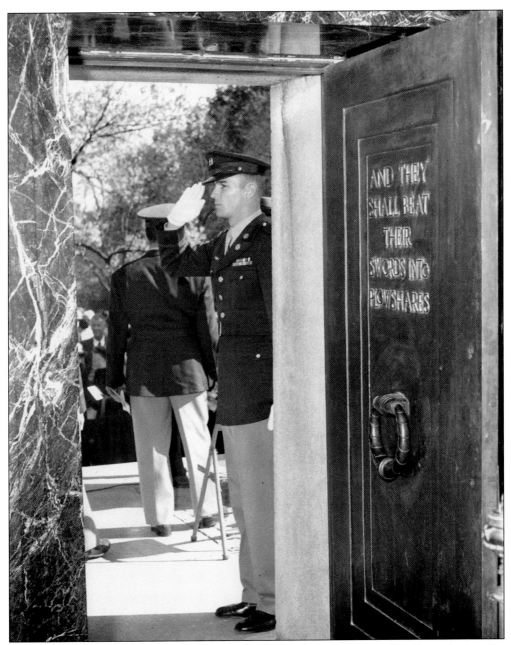

A cadet officer stands at attention while the band plays the national anthem during the Memorial Bell Tower dedication. The photograph was taken inside the Shrine Room of the tower and shows the bronze door and the walls of Italian marble. (Courtesy of North Carolina State University.)

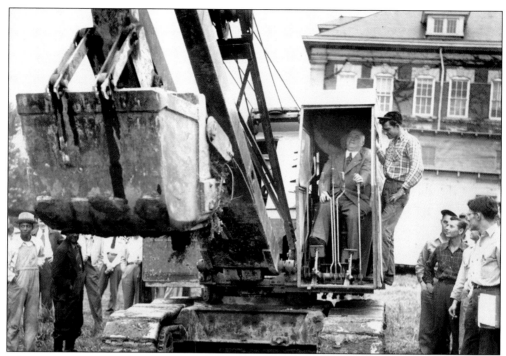

John Lampe became the dean of engineering in 1945. He is pictured operating the steam shovel at the groundbreaking of the Riddick Engineering Laboratory. Construction was made possible after the General Assembly appropriated $15.3 million for improvements on campus. The building was completed in 1950. (Courtesy of North Carolina State University.)

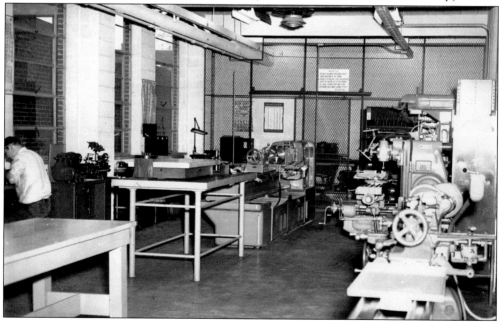

The Riddick Engineering Laboratory introduced a new era in the development of the department. The image above shows the interior of the new precision machine shop in the laboratory. (Courtesy of North Carolina State University.)

In 1945, the importance of flight caused aeronautical engineering to become an important major. Students are shown working on a radial aircraft engine. (Courtesy of North Carolina State University.)

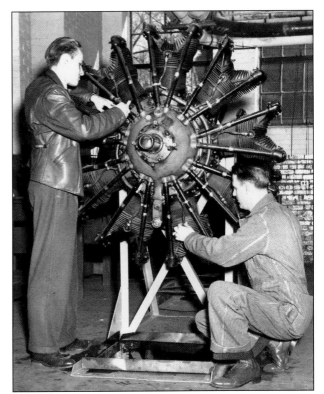

Jet technology was the future of flight in 1949. Students are shown in the Riddick Laboratory with a jet engine. (Courtesy of North Carolina State University.)

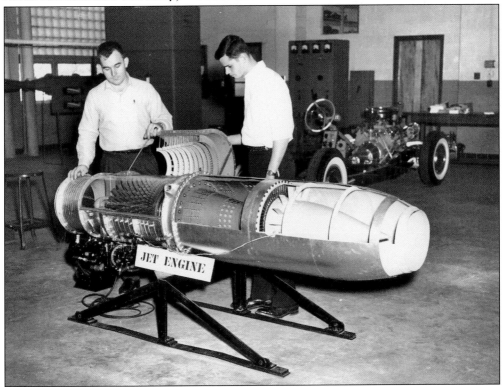

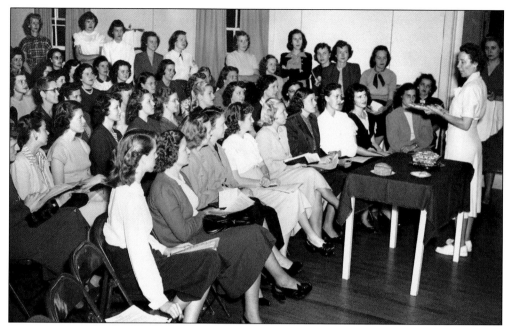

Females became a regular sight on campus during the war years. They were encouraged to serve the United States by assuming occupations that were traditionally male dominated. Until this time, few co-eds studied at State because they were encouraged to attend the College for Women in Greensboro. This photograph, *c.* 1950, doesn't reveal that women were outnumbered by men 48 to 1. (Courtesy of North Carolina State University.)

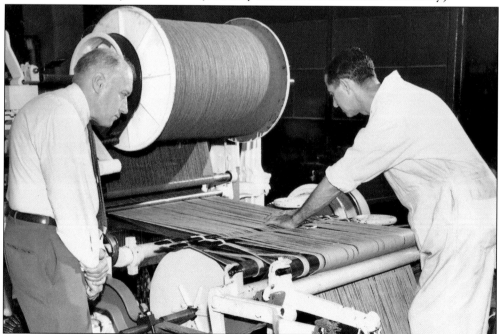

When the velvet carpet loom was installed in the School of Textiles in July 1951, it strengthened the school's instructional program on weaving. Students are shown demonstrating the machinery. (Courtesy of North Carolina State University.)

The School of Design, established in 1948, was headed by Dean Henry Kamphoefer and George Matsumoto. It was housed in surplus army barracks near Patterson Hall. By 1976, degrees in architecture, landscape architecture, environmental design, and urban design were offered. Graduate degrees were also added. (Courtesy of North Carolina State University.)

Prof. E. J. Brown and Joseph Lynn of the physics department adjust the sampling system of the nuclear reactor in September 1953. The Burlington Nuclear Laboratories contained the first nuclear reactor approved by the federal government for use in college research. (Courtesy of North Carolina State University.)

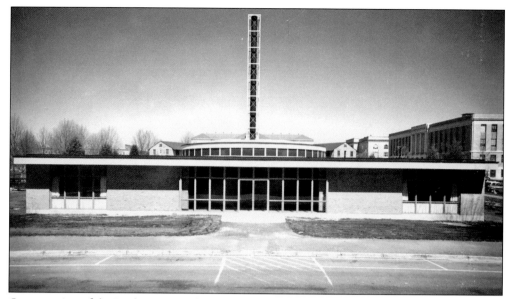

Construction of the Burlington Nuclear Laboratory gave State a head start in the development of a nuclear engineering program. Clifford Beck, a member of the Manhattan Atomic Bomb Project, was recruited as head of the physics department. The college became a member of the Oak Ridge Institute of Nuclear Studies. The curriculum began in 1950. (Courtesy of North Carolina State University.)

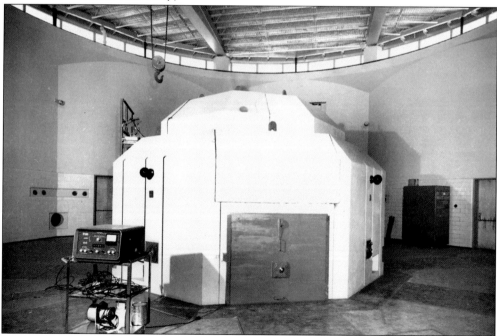

The facility to house the reactor was made possible with the help of Burlington Industries. The Atomic Energy Commission furnished the uranium-235 isotope that was necessary to fuel the reactor, which was activated in 1953. The reactor was placed in the center of a room that was 8 feet below ground level, 60 feet in diameter by 35 feet high. (Courtesy of North Carolina State University.)

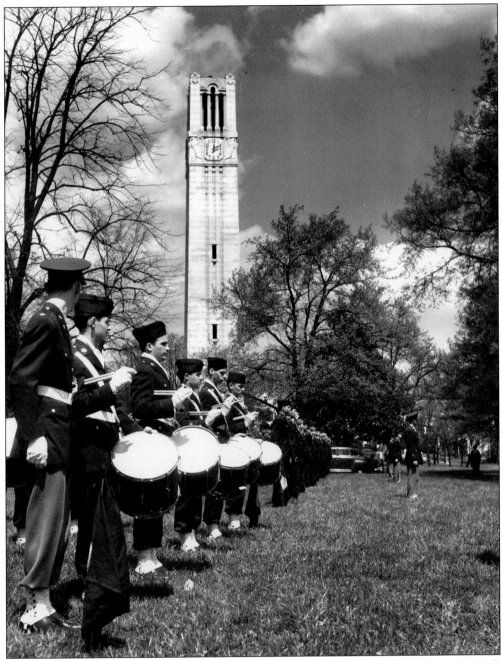

The ROTC Drum and Bugle Corps are shown above waiting in front of the Memorial Bell Tower to salute Gov. William Kerr Scott. He was attending the Army Day parade. (Courtesy of North Carolina State University.)

Ira O. Schaub (class of 1900), pictured here with colleagues, was the dean of the School of Agriculture and was prominent in the establishment of national 4-H clubs. He was among a small group that encouraged the origin of the university archives in 1939. (North Carolina State University.)

The students were discontented with some of the policies during the 1950s, including the way the student supply store was run. This was due to the fact that Harrelson failed to consider student opinions. The Carey H. Bostian administration made attempts to coordinate with the student body. Students are pictured above reorganizing the student supply store. (Courtesy of North Carolina State University.)

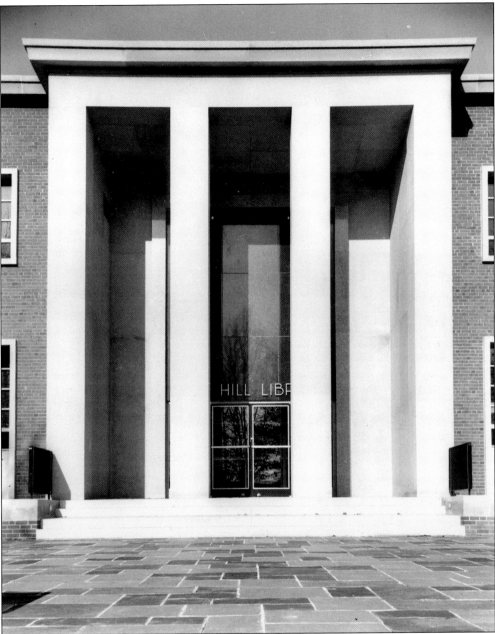

A new D. H. Hill Library was constructed on Hillsborough Street and fronted the Brickyard. The facility was considered long overdue, especially since the library had been labeled one of the worst college libraries in the country. The vacated building was renamed Brooks Hall and remodeled for the College of Design. (Courtesy of North Carolina State University.)

As sports events gained importance in the 1950s, so did Homecoming. Bonfires, pep rallies, and parades became a tradition. The 1959 Sigma Kappa Homecoming parade float is shown above. Sigma Kappa was the first national sorority on campus. (Courtesy of North Carolina State University.)

The sororities and fraternities conducted friendly competitions for activities during Homecoming. Phi Kappa Alpha's homecoming float is shown above, c. 1959. (Courtesy of North Carolina State University.)

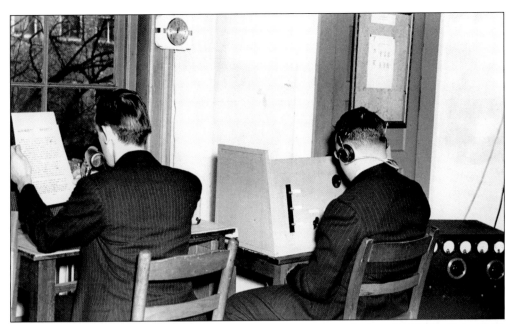

Radio was begun in 1922; however, WKNC Radio was organized after World War II. In 1959, the station provided coverage only to the campus. However, by 1972, it transmitted into the Raleigh area. (Courtesy of North Carolina State University.)

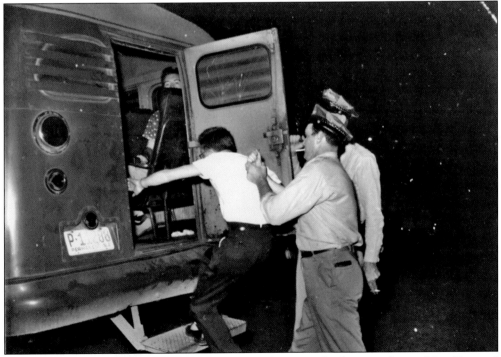

In the 1950s, "panty raids" were a much talked about mischief among fraternities. Pictured above are unidentified State students being arrested by the Raleigh police while attempting a "raid" on Meredith College on May 28, 1955. (Courtesy of North Carolina Office of Archives and History.)

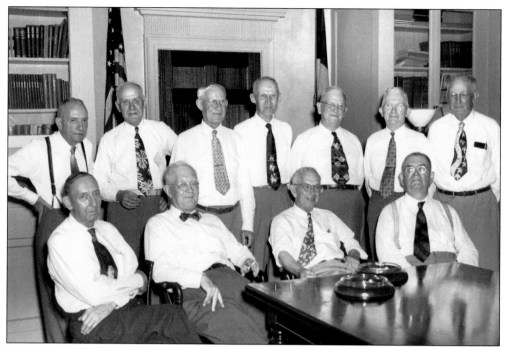

The 11 men of 1900 celebrated their 50th anniversary in 1950. They are, from left to right, as follows: (first row) R. H. Morrison, Garland Jones, I. O. Schaub, and W. L. Pearce; (second row) R. M. Wagstaff, R. L. Barnhardt, George R. Harrel, J. W. Shore, John T. Taylor, Kemp Alexander, and W. T. Smith. (Courtesy of North Carolina State University.)

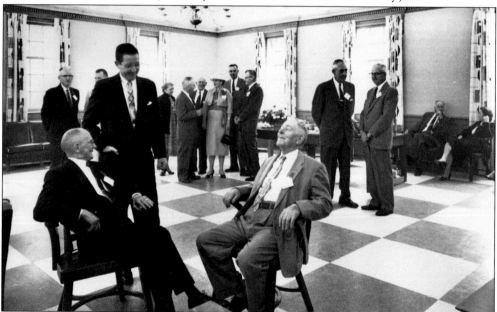

The newly remodeled Alumni Memorial Building was dedicated in May of 1957. Consolidated University president-elect William C. Friday, class of 1941, is shown with the last surviving members of the first graduating class. Seated from left to right are Sam Young and Walter J. Matthews. (Courtesy of North Carolina State University.)

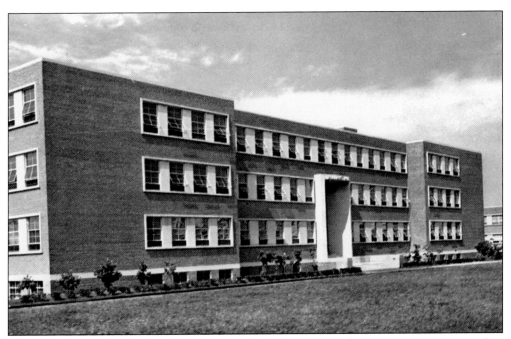

Williams Hall was completed in 1953 to house the agronomy department. It was named to honor Prof. C. B. Williams, who was the first graduate of the college to become director of the Agriculture Experiment Station. (Courtesy of North Carolina Office of Archives and History.)

Carey H. Bostian's installation as chancellor was held on February 22, 1954. The address was delivered by Gov. William Bradley Umstead. Bostian resumed teaching genetics in human affairs after resigning as chancellor. (Courtesy of North Carolina Office of Archives and History.)

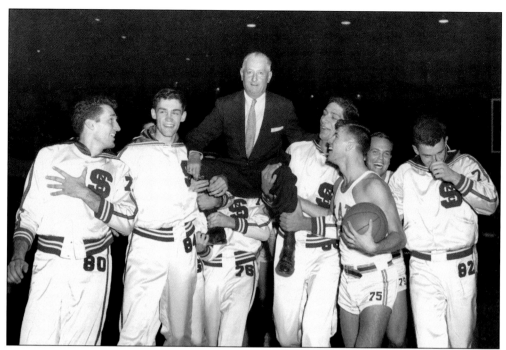

The North Carolina State basketball team is shown here in 1955. (Courtesy of North Carolina State University.)

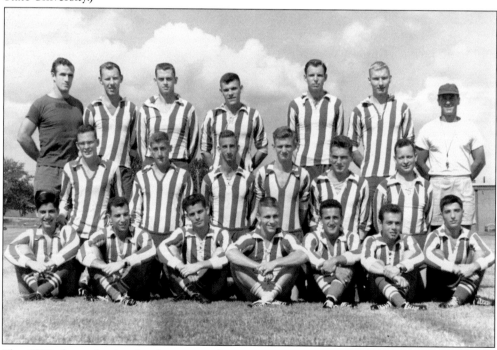

The 1950s brought the development of various sports teams, and fan interest expanded beyond football and basketball. Track and field, wrestling, swimming, and soccer were among the new varsity teams. The 1959 men's soccer team is pictured. (Courtesy of North Carolina State University.)

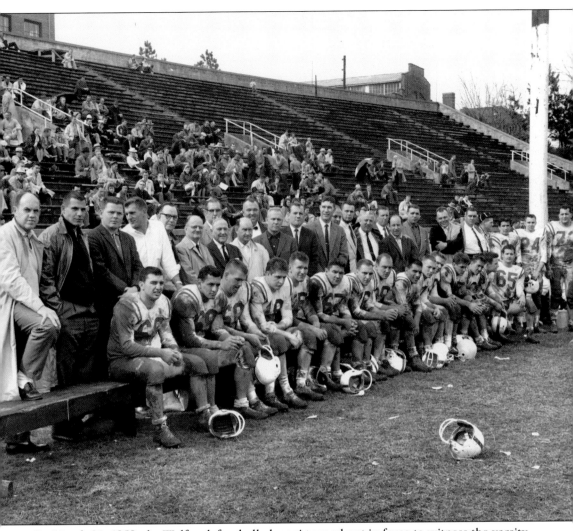

On March 21, 1959, the Wolfpack football alumni turned out in force to witness the varsity versus the alumni game. The game was an annual event that closed spring practice. (Courtesy of North Carolina State University.)

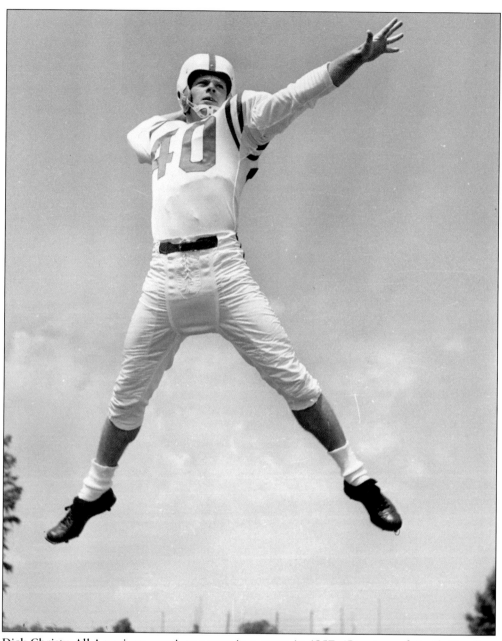

Dick Christy, All-American, receives a pass in a game in 1957. (Courtesy of North Carolina State University.)

Six

A RESEARCH UNIVERSITY

There was talk of dropping the name State College as early as the 1950s. In 1960, serious efforts were undertaken by the Student Government and the Alumni Association to rename the college North Carolina State University. There was opposition from the consolidated university system led by Gov. Terry Sanford. Detractors attempted to create the University of North Carolina at Raleigh. Students were outraged and picketed. The die-hard fans, alumni, students, and faculty did not want to lose the 70 years of State tradition and did not want the identity of the liberal arts programs at UNC. In June 1963, the legislature decided that State should become North Carolina State of the University of North Carolina at Raleigh. Future governor and State graduate Robert W. Scott was among those insisting on North Carolina State University.

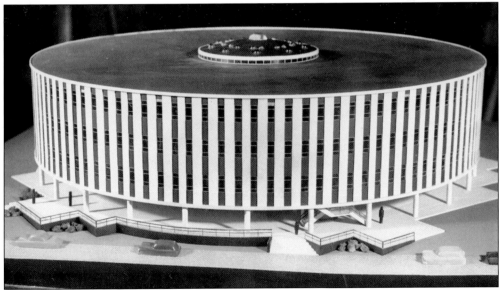

Harrelson was a futuristic facility for 1961. It was designed to house the School of Liberal Arts and the Department of Mathematics. Its circular shape provided space for 4,500 students. The image above is the architectural model that was submitted to the administration in the 1950s. (Courtesy of North Carolina State University.)

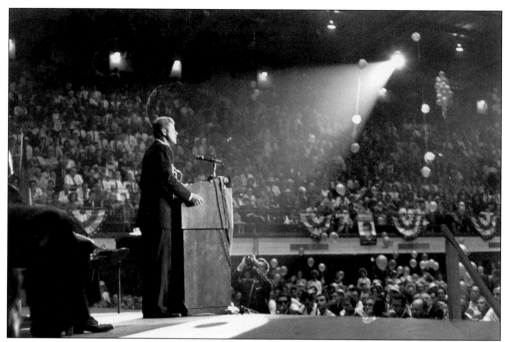

John Kennedy was a presidential candidate when he addressed the crowd of 10,000 supporters in Reynolds Coliseum on September 17, 1960. The coliseum became an important gathering place for the general public as well as for students. (Courtesy of North Carolina State University.)

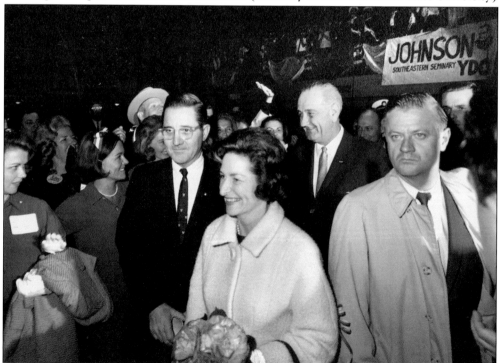

Lyndon Johnson visited the campus and spoke at Reynolds Coliseum in 1964. (Courtesy of North Carolina State University.)

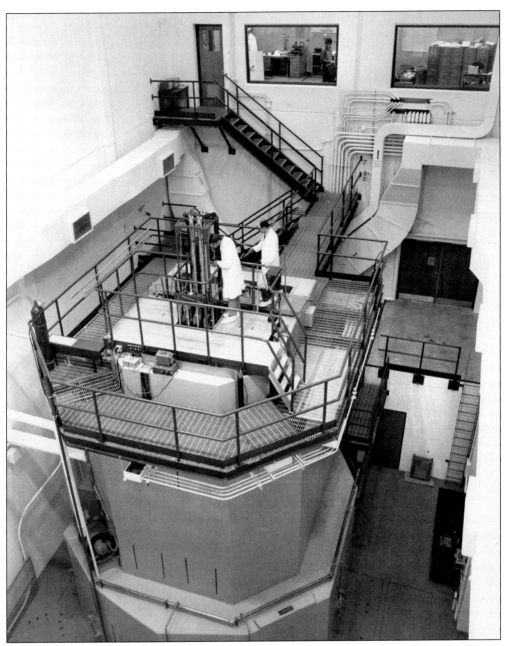

The Pulstar nuclear reactor was built in 1971 as the central feature of the new, main section of the Burlington Engineering Laboratory. It was the fourth reactor constructed at State. At one time, the college had two reactors in operation. State pioneered the first bachelor's, master's, and doctoral programs in nuclear engineering. (Courtesy of North Carolina State University.)

Even though membership in ROTC was no longer required of all students, it remained a popular program into the 1960s. The Air Force ROTC is shown above enjoying an egg toss. (Courtesy of North Carolina State University.)

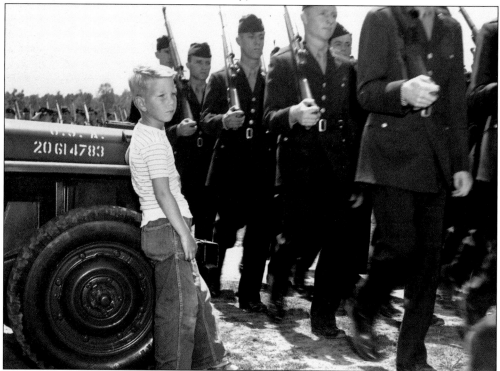

A young boy is pictured above as he watches the ROTC drill in 1960. At the time, drill was cut from three hours per week to two hours. (Courtesy of North Carolina State University.)

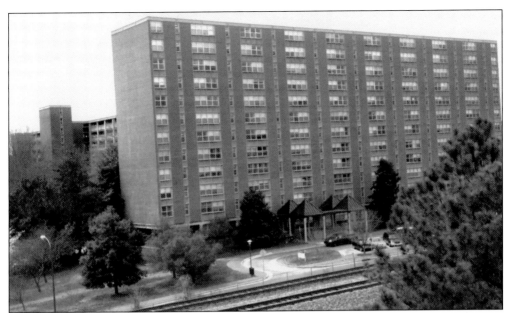

Sullivan Residence Hall was constructed in 1966 on land on the south campus and fronted the railroad tracks. It was named to honor William H. Sullivan of the class of 1913; he was the founder of an engineering firm, the mayor of Greensboro, and the president of the Alumni Association from 1933 to 1935. (Photograph by Burke Salsi.)

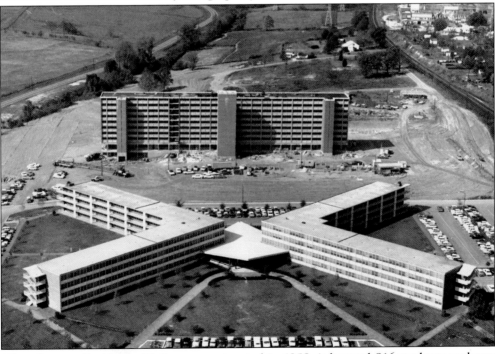

When Bragaw Residence Hall was constructed in 1958, it housed 816 students and was the largest dorm in the state. It was one of the first high-rise dormitories on campus. Two other high-rises, Sullivan and Lee, were built west of Bragaw. (Courtesy of North Carolina State University.)

While Riddick Stadium was undergoing repairs in 1968, pranksters staged a fake accident. Workmen arriving on the scene discovered a fake body, causing a moment of consternation by workers and a good news story for the students. (Courtesy of North Carolina State University.)

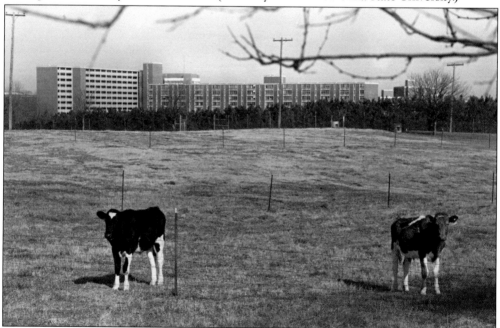

State continued its research and development of animal husbandry and veterinary programs into the 1980s. Tending to the campus herd continues to be part of multiple programs of study. (Courtesy of North Carolina State University.)

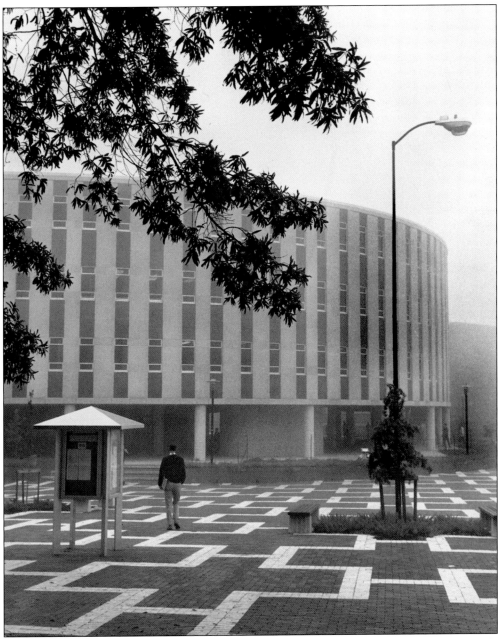

Many protests took place in the 1960s, including the renaming of the university, the draft, U.S. involvement in Vietnam, and civil rights issues. Most protests were organized or staged in the "Brickyard." Likewise, the area was a gathering place for celebrations after winning games. (Courtesy of North Carolina State University.)

Women were not a strong force on campus until the 1960s. Cathy Sterling was the first woman to become president of the student body in 1971. (Courtesy of North Carolina State University.)

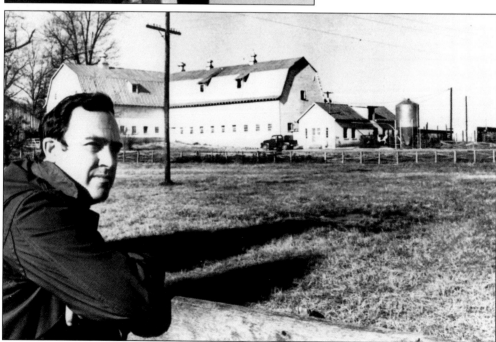

Gov. Robert W. Scott, one of the first three alumni to become governor of North Carolina, is shown on his farm at Haw River in 1971. He was instrumental in having "university" substituted for "college" when State became North Carolina State University. (Courtesy of North Carolina State University.)

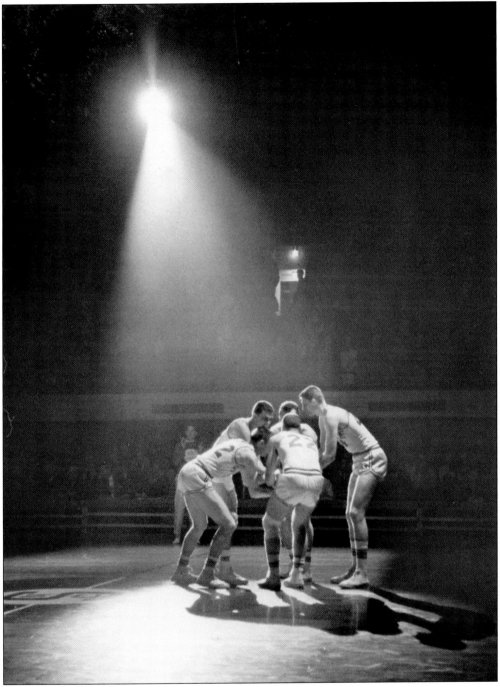

The spotlight shines on the North Carolina starting players as they are introduced before a game at Reynolds Coliseum in 1963. (Courtesy of North Carolina State University.)

Between 1947 and 1967, football fans overflowed Riddick Stadium and plans were underway for a new facility. (Courtesy of North Carolina State University.)

Roman Gabriel is pictured above in 1961. He was an All-American quarterback and is remembered for his brilliance. He played in Riddick Stadium under Coach Earle Edwards, who was known for re-establishing the football program after World War II. (Courtesy of North Carolina State University.)

Track and field became more important after World War II, when the sports program was revived. Swimming and cross-country teams were successful in conference championships in the 1960s. (Courtesy of North Carolina State University.)

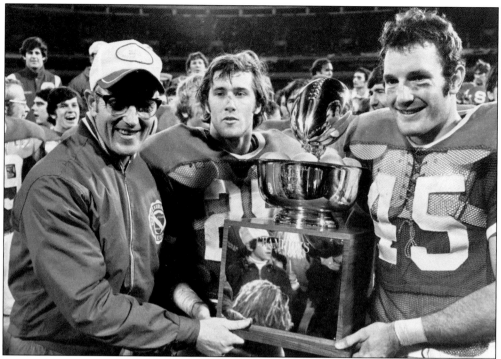

Lou Holtz served as the head football coach from 1972 to 1977. He had the best four-year win/loss record (33-12-3) in the history of the college. He led his 1972 team to a Peach Bowl Championship and the 1973 team to an ACC Championship and a Liberty Bowl win. He is shown with 1972 team members receiving the Peach Bowl trophy. (Courtesy of North Carolina State University.)

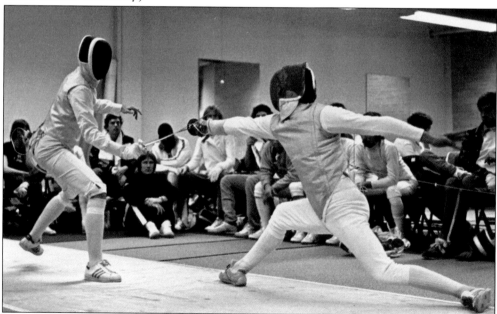

The fencing team was granted varsity status in 1952. The 1979 team is shown above during competition. (Courtesy of North Carolina State University.)

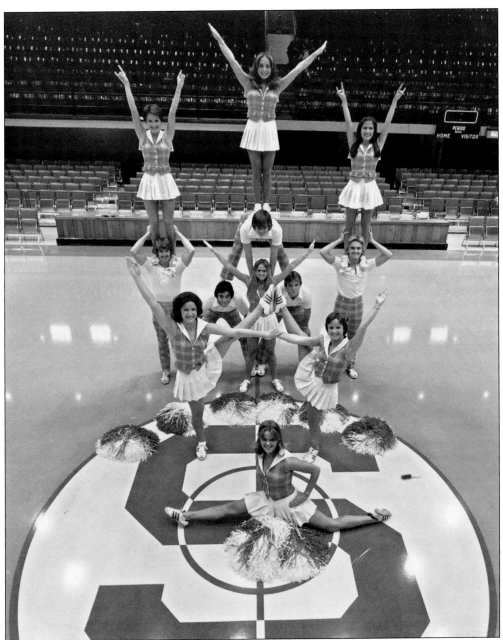

North Carolina State cheerleaders are pictured in center court in Reynolds Stadium in 1975. This was the year that women's sports expanded as women's enrollment increased. Kay Yow became one of the first full-time women's coaches in the nation. (See page 106.) (Courtesy of North Carolina State University.)

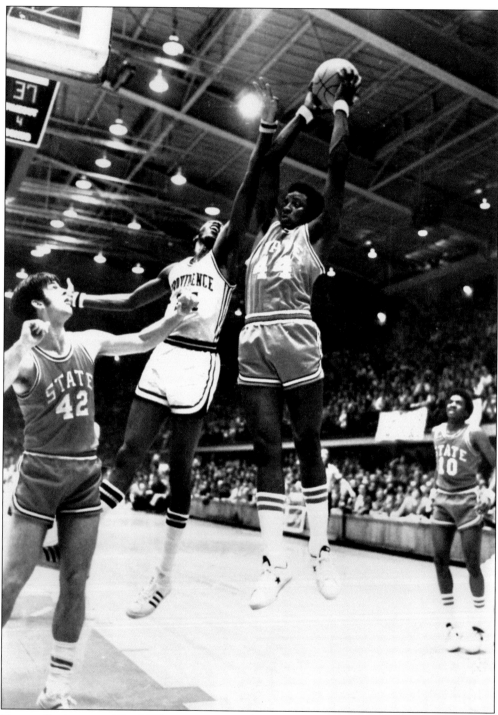

Tommy Burleson and David Thompson were All-Americans. They were part of the 1972 and 1973 teams that brought a great deal excitement to North Carolina State basketball. The team won the ACC Championship in 1973. (Courtesy of North Carolina Office of Archives and History.)

Seven

WIDENING THE VISION

Today outreach and extension is more important than ever. The programs include engineering, agriculture, textiles, mathematics, and veterinary. The teaching hospital of the College of Veterinary Science handles thousands of clients and is the main East Coast referral hospital for dogs with cancer.

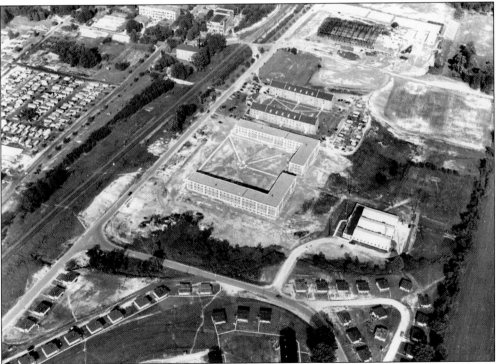

This aerial view shows the many campus changes that were begun post–World War II. Upper right reveals the progress on the Reynolds Coliseum as well as the layout of new roads. This was a jumping off point for the future campus. (Courtesy of North Carolina Office of Archives and History.)

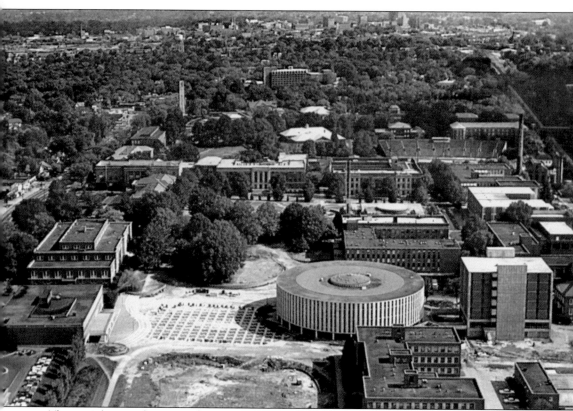

The aerial view above is a fast-forward to 1970. It shows the Harrelson Building and the Brickyard (foreground). The modern Raleigh skyline is in the background. In 2005, the administration decided that Harrelson would be replaced by a new building. (Courtesy of North Carolina Office of Archives and History.)

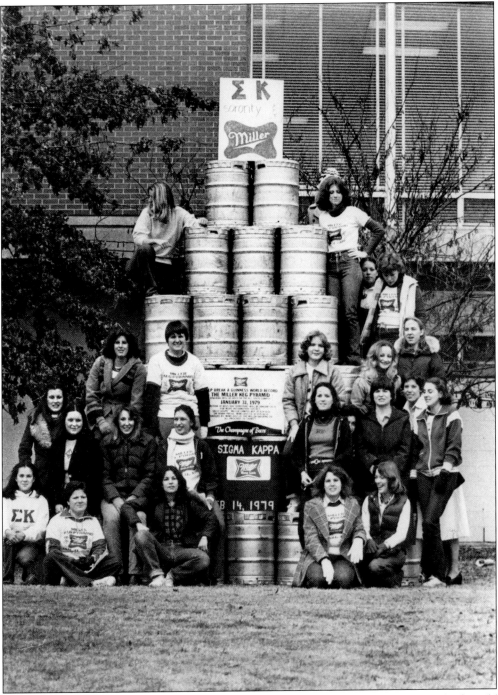

The sisters of Sigma Kappa Sorority set a world record (confirmed by *Guinness Book of World Records*) on Harris Field on February 14, 1979. They constructed a pyramid of 140 empty kegs, representing 2,170 gallons of drained beer. The sorority collected $325 for charity from sponsors. (Courtesy of North Carolina State University.)

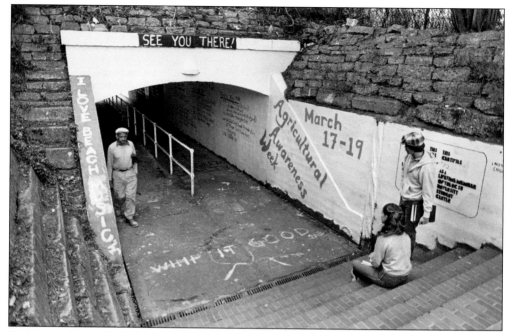

Bridges and tunnels were constructed to connect the south campus on one side of the tracks with the main campus on the other side. These provided convenient routes for students to safely access campus buildings. (Courtesy of North Carolina State University.)

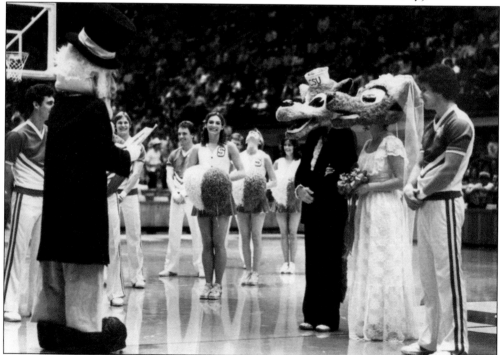

A "he-wolf" and a "she-wolf" mascots were married in a mock wedding during half-time at a 1981 basketball half-time. The game was with Wake Forest, and their Deacon mascot officiated. (Courtesy of North Carolina State University.)

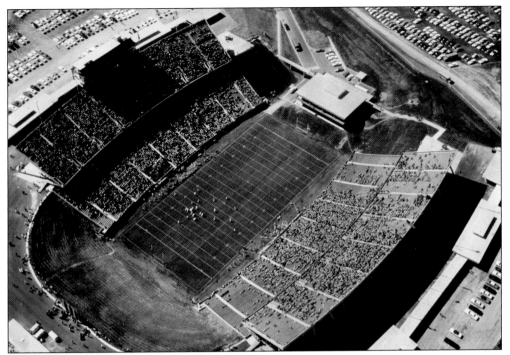

Carter Stadium replaced Riddick Stadium in 1966. Increased enrollment and the lack of parking made the move necessary. The Wolfpack Club conducted a fund-raising campaign to finance the facility. The stadium was named for Nick and Harry Carter, graduates of the School of Textiles and the first donors. (Courtesy of North Carolina State University.)

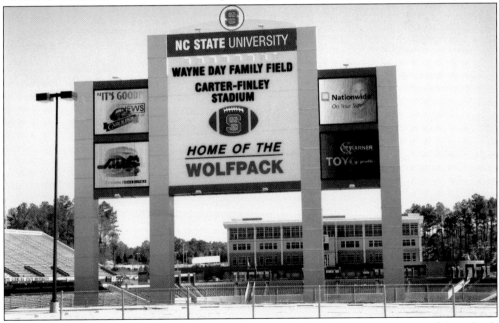

The largest single donation for the stadium fund came from A. E. Finley, the owner of the Raleigh Tractor and Equipment Company. Finley had an active interest in supporting NCSU sports. The facility was renamed Carter-Finley Stadium in 1979. (Photograph by Burke Salsi.)

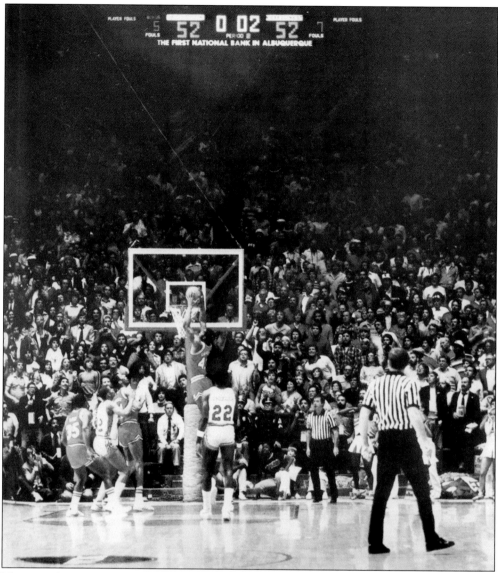

The 1983 basketball team upset Houston to win the National Championship on April 4.
Dereck Whittenburg hit two consecutive baskets with 1 minute and 59 seconds left on the
clock and tied the game. With 3 seconds to go, his ball was short; however, Lorenzo Charles
dunked it to win the game. (Courtesy of North Carolina State University.)

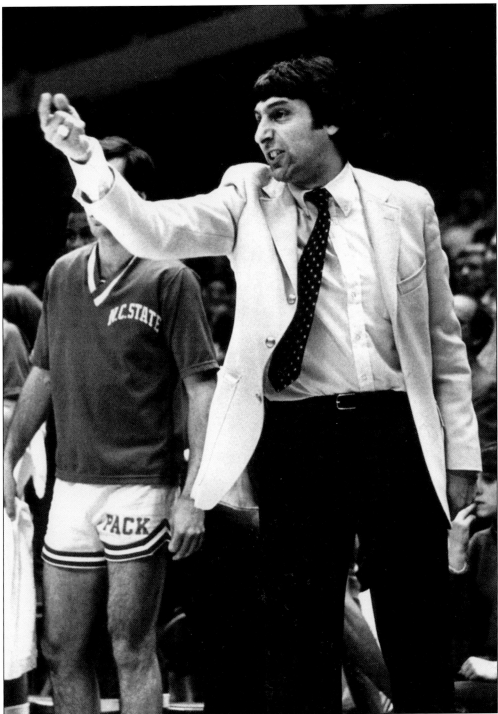

Jim Valvano coached the 1983 basketball team to win the National Championship. During his career, he took eight teams to the NCAA championship and was named ACC Coach of the Year in 1983. He served North Carolina State as athletic director between 1986 and 1989. (Courtesy of North Carolina State University.)

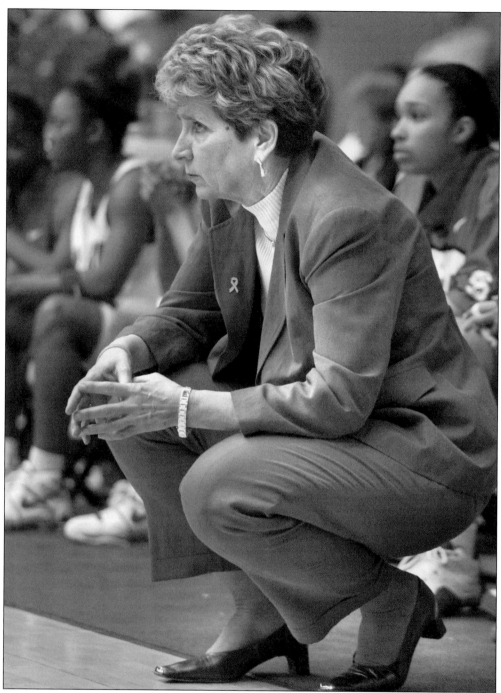

Women's basketball was the first major women's team sport to be established in 1975. Kay Yow served as coach and coordinator of women's athletics. By 1882, Wolfpack women participated in 11 sports. Yow's 1975–1976 team won the Class A Championship and participated in the National Invitational Tournament. She has coached teams at the Goodwill Games, the World Championships, and the Olympics. (Courtesy of North Carolina State Athletic Media Relations.)

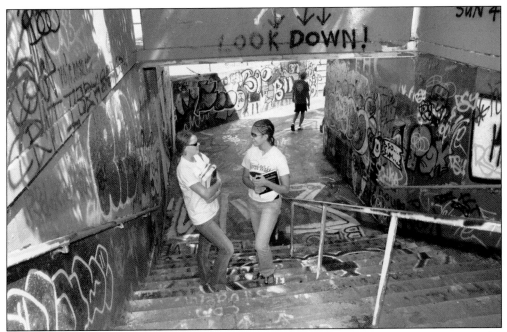

Kendal Wells (left) of Richmond and Carina Bitticks-Alston of Greensboro are among the thousands of students who access the main campus from the south campus by way of the "free expression" tunnel. The tunnel is not just a passageway; it is an experience. (Photograph by Burke Salsi.)

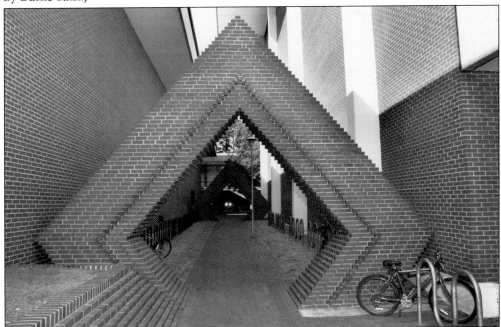

The brick sculptures between the Talley Student Center and the Price Music Center are one example of the eclectic structures on campus. There is an ongoing struggle to blend the original campus of 1900 with structures that fill the needs of a 2005 student body. (Photograph by Burke Salsi.)

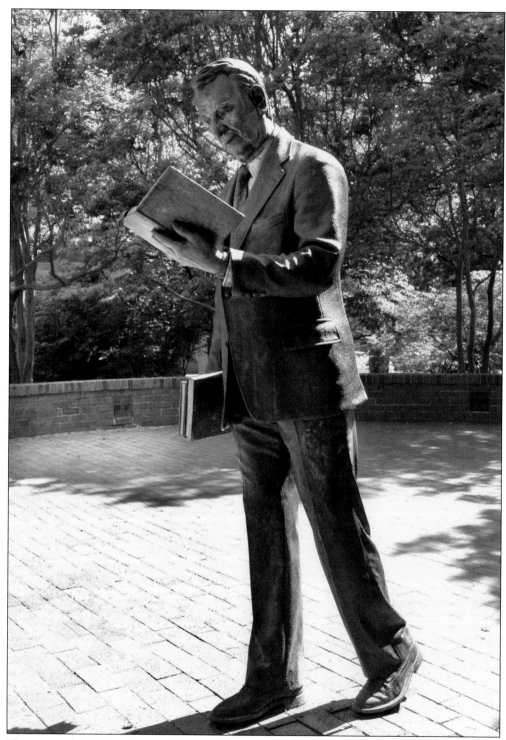

The statue of M. E. Gardner was placed in the Gardner Arboretum on January 8, 1973, to honor the memory of Gardner, who served as a professor of horticulture from 1956 to 1965 and was the head of the horticulture department from 1931 to 1956. (Photograph by Burke Salsi.)

Eight

THE CENTENNIAL CAMPUS

As we break ground on the Centennial Campus, as the volume of our research activity breaks new records every year, and as business and industry express increasing interest in developing closer relationships with our research, we stand on the threshold of becoming a significant research university of national importance. That is the challenge we face for our next century of development.

—Chancellor Bruce R. Poulton, September 1986

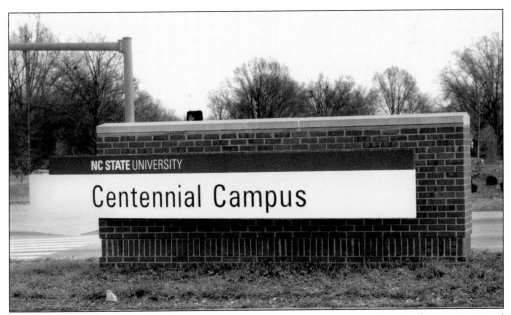

The Centennial Campus is North Carolina State University's vision for the future. Its 1,334 acres consists of multi-disciplinary research and development neighborhoods that combine university studies with corporate and government facilities. Future plans include residential housing, a hotel, a conference center, a golf course, and recreational facilities. (Courtesy of Burke Salsi.)

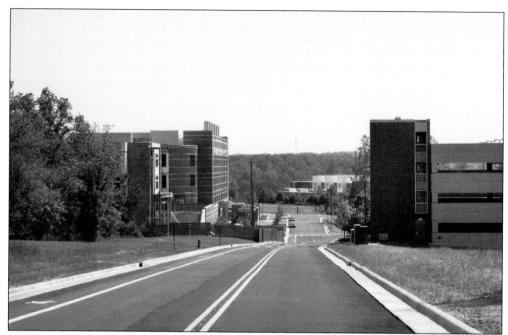

Turn off of Avent Ferry Road, and take a left onto the Centennial Campus. Wide boulevards lead to modern research buildings, parking garages, student facilities, and the construction of new buildings. Projections by North Carolina State University predict 5,500 students by 2007. (Photograph by Burke Salsi.)

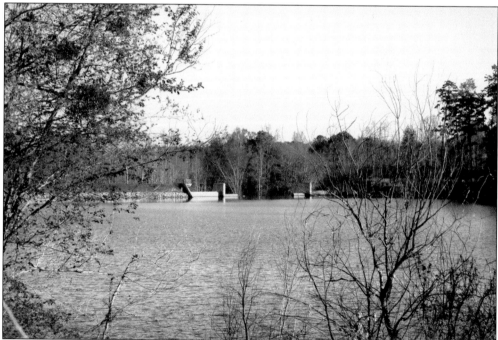

The Centennial Campus has a beautiful setting on the shore of Lake Raleigh. Students in various programs enjoy classes and research on this state-of-the-art campus. Future plans include a walking trail around the lake. (Photograph by Burke Salsi.)

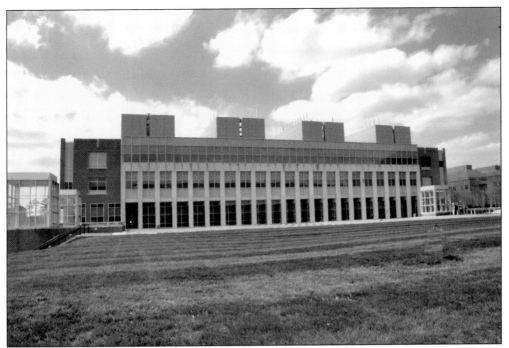

The Engineering Graduate Research Center is the also the site of the Power Semiconductor Research Center and the Center for Advanced Computing and Communication. By 2007, the population of the campus will include 1,800 faculty, staff, and post-doctoral students. (Photograph by Burke Salsi.)

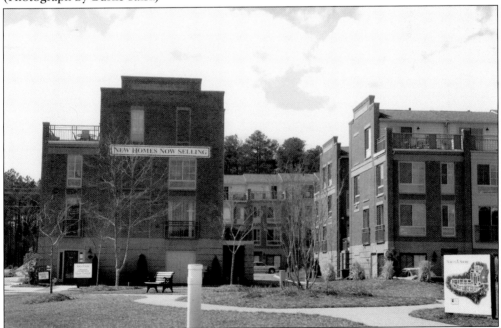

The new campus is a "community of tomorrow." The partnership with scholars, industry, and students requires professional residences within walking distance of the campus. The North Shore townhomes are luxurious residences built on the lake. (Photograph by Burke Salsi.)

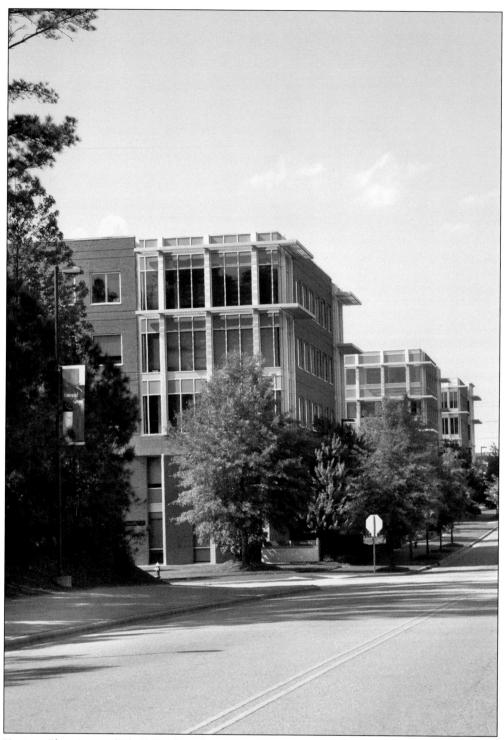

Venture Place is a multi-building location. One of its partners is the United States Department of Agriculture. The future presence will include government employees alongside faculty and students. (Photograph by Burke Salsi.)

The Environmental and Molecular Toxicology Building is part of the new campus. In his installation speech, Chancellor James Oblinger said, "Centennial Campus is not just a place; it's a concept—a concept that is being applied throughout the University, blending our extension mission with leading-edge research and experimental education to generate new age development." (Photograph by Burke Salsi.)

The new textiles building on the Centennial Campus houses textiles and apparel technology and management, textile engineering, chemistry and science, textile extension, and applied research. It also features a large library for students and researchers. (Photograph by Burke Salsi.)

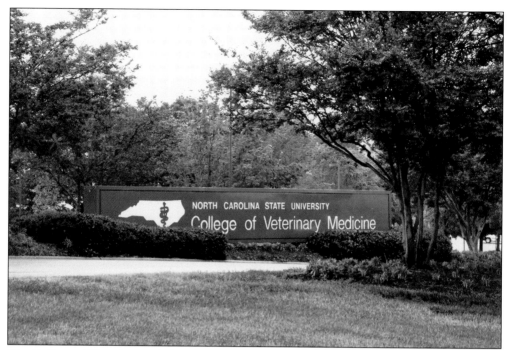

The College of Veterinary Medicine opened in August of 1981. It is a center for veterinary education and animal health research. It is located on a 182-acre farm near the main campus on Blue Ridge Road. It offers the degree of doctor of veterinary medicine. (Photograph by Burke Salsi.)

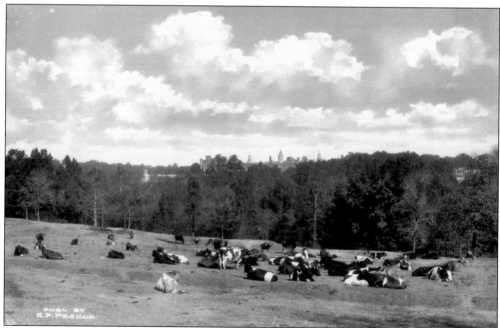

Cows are among the animals raised at the College of Veterinary Medicine. The Laboratory Animal Resource unit maintains more than 25 vertebrate and invertebrate species. (Courtesy of North Carolina Office of Archives and History.)

There are more than 20 buildings on the veterinary campus. Facilities are used for instruction, research, and clinical services. (Photograph by Burke Salsi.)

The Erdahl-Cloyd Student Union was built in 1954 to house the student union. It is adjacent to the new wing of the D. H. Hill Library and is a student center. Students refer to the first floor facilities as "the atrium." There is a food court offering fast food as an alternative to campus cafeteria dining. The other floors are occupied by library services. (Photograph by Burke Salsi.)

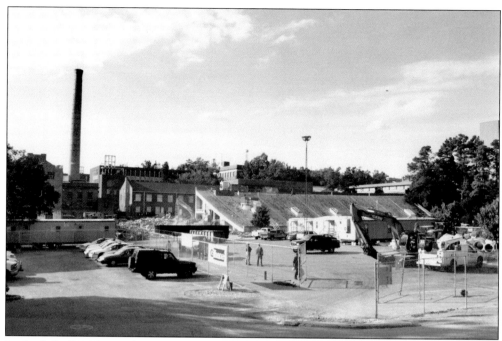

In the fall of 2003, wrecking crews tore down the old Riddick east bleachers that were built with Works Progress Administration funding in the 1930s. The field, which is considered hallowed ground to many alumni, is now a parking lot, referred to as the Riddick Lot. (Photograph by Burke Salsi.)

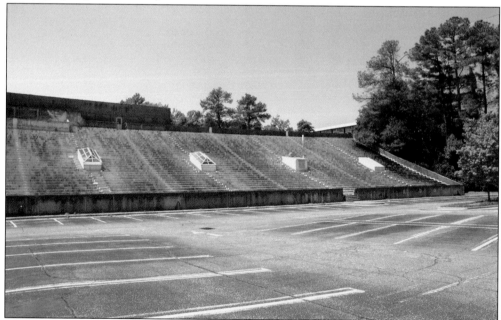

The concrete bleachers on the west side of Riddick Field were integrated into practical use for the power plant. This is a spring 2005 view showing that old Riddick Field was paved after the top photograph was taken. New plans include the demolition of the remaining bleachers for the Yarborough Plant renovation. (Photograph by Burke Salsi.)

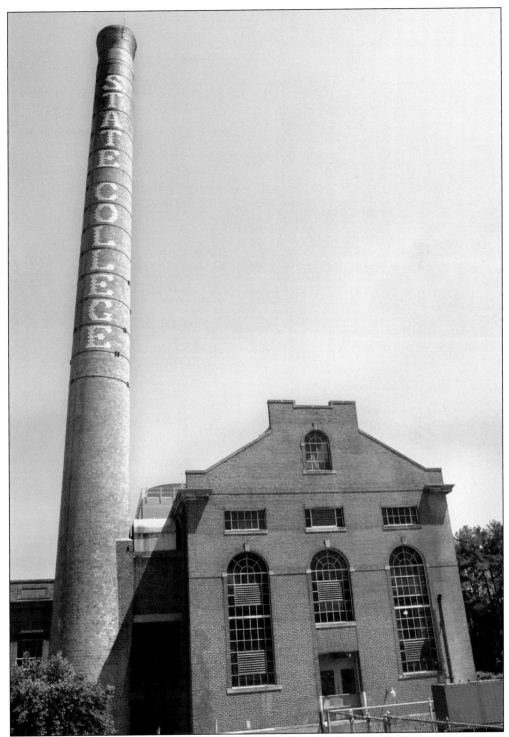

The Yarborough Steam Plant includes the original 1906 power plant facility. During 2005, it underwent renovation and expansion. The old State College chimney is now an icon of the university's history. (Photograph by Burke Salsi.)

The Student Health Center is a state-of-the-art medical facility that is open to serve the entire student body. Its personnel includes five doctors and modern diagnostic equipment. (Photograph by Burke Salsi.)

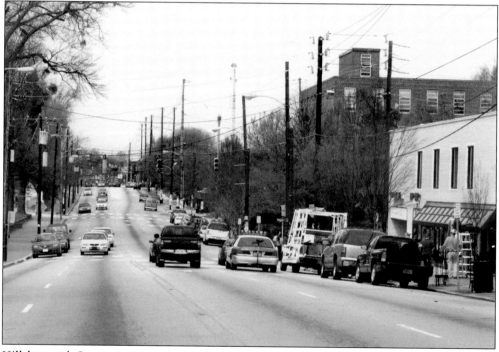

Hillsborough Street continues to be the main route by the NCSU campus. It leads directly to Capitol Square in Raleigh. This is Main Street for students searching for a place to dine off campus. (Photograph by Burke Salsi.)

The D. H. Hill Library was built in stages. The west wing of the original library is attached to structures shown above. This southwestern view shows the 1972 book-stack tower, with space for one million volumes, and the 1990 book-stack tower for half a million books. Overcrowding of the facility has led to renovations that will be completed in 2006. (Courtesy of Burke Salsi.)

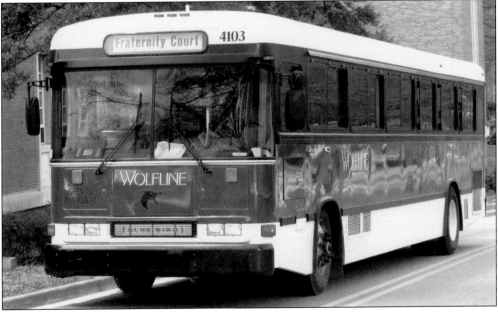

The university has its own Wolfline bus service that runs throughout the many campuses. Since North Carolina State is the largest university in North Carolina, with almost 30,000 students, it is not possible to provide enough on-campus parking to accommodate the students and 1,700 faculty members. (Courtesy of Burke Salsi.)

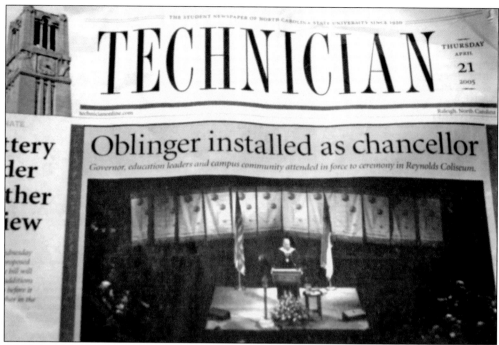

The *Technician* of April 21, 2005, announces the installation of the 13th chancellor. The newspaper is student-run and has a circulation of approximately 17,000. (Courtesy of Burke Salsi.)

The office of the *Technician* has come a long way since its beginnings in the early 1900s. Its modern office is complete with computers and photo-copying equipment that was unheard of in the early years. The newspaper is published on Monday, Wednesday, and Friday during the fall and spring and weekly during the summer. (Courtesy of Burke Salsi.)

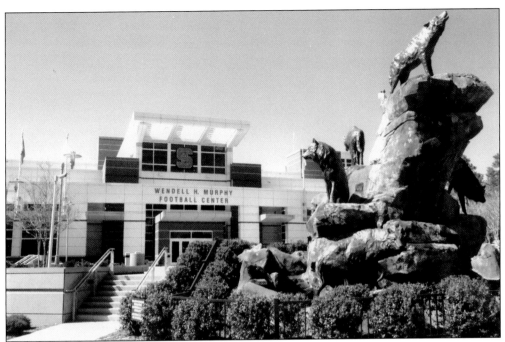

The Wendell Murphy Football Center is a state-of-the-art football complex adjacent to Carter Finley Stadium. The outdoor sculpture was executed by former North Carolina State football player Dick Idol, the now famous wildlife artist. The Wolfpack Club commissioned the 30-foot-tall bronze sculpture depicting six wolves on a mountain. (Courtesy of Burke Salsi.)

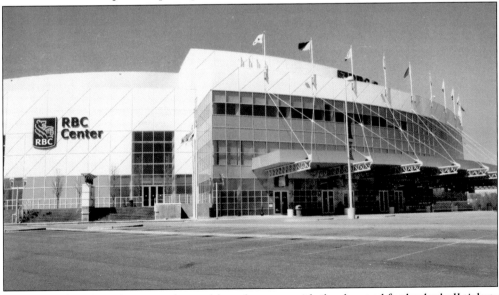

North Carolina State has never been able to keep up with the demand for basketball tickets from students and fans. The $158 million RBC Center was opened on October 29, 1999. It is home to Wolfpack basketball and is also used by other groups. Construction was possible when the Wolfpack Club funds and university funds were subsidized by tax revenue from Wake County and the city of Raleigh, the state of North Carolina, and revenue bonds. (Courtesy of Burke Salsi.)

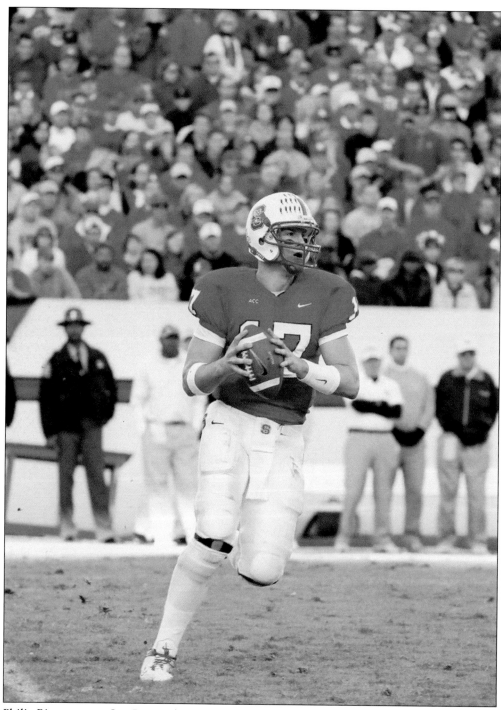

Philip Rivers, now a San Diego Charger, was part of State's history and football record books. As a quarterback from 1999 to 2003, Rivers was the second leading passer in NCAA history with 13,484 yards. He finished second in the NCAA with yards of total offense and was fifth with 95 touchdowns. He was the first quarterback in ACC history to throw 3,000 yards in three different seasons. (Courtesy of North Carolina State Athletic Media Relations.)

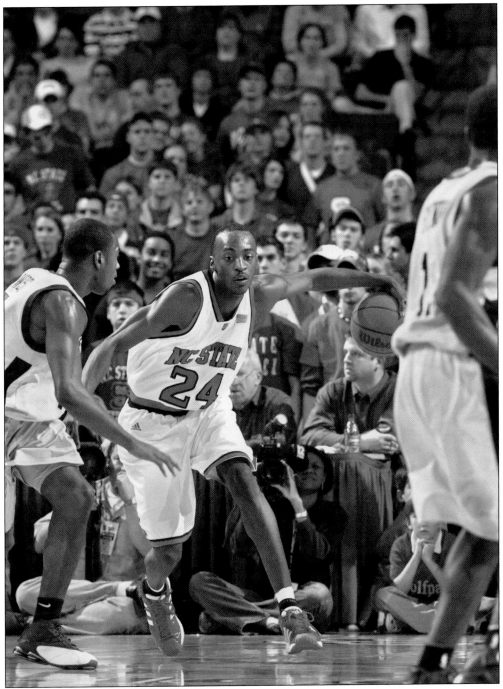

During Julius Hodge's years at State, he was known as the man who had the skills to do it all. During his junior year, he was the ACC Player of the Year. He made a name for himself on a national scale when he stayed at State for his senior year and was part of the first team to reach the NCAA Regional Semifinals since Coach Jim Valvano's team in 1989. He was known as the epitome of a student-athlete. Hodge graduated in May 2005. (Courtesy of North Carolina State Media Relations.)

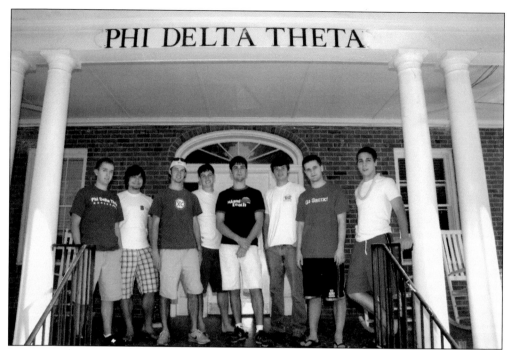

Phi Delta Theta fraternity was the winner of the Caldwell Cup four years in a row. Shown on the steps of the house are, from left to right, Ryan Chamberlain, Ashton Webb, David Jones, David Myers, Burke Salsi Jr., Nick Ward, Brent Wilson, and Dale Meisenbach. (Photograph by Burke Salsi.)

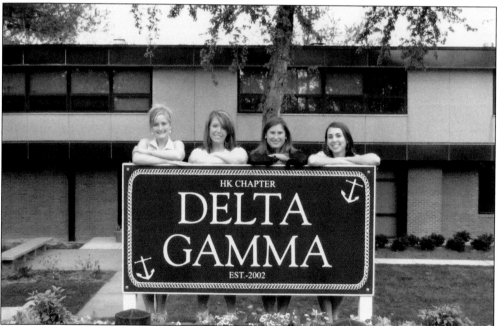

Delta Gamma sorority, established in 2002, is located on Fraternity Court, designed by renowned architect George Matsumoto, of the design school. The girls of Delta Gamma are shown in front of their house. (Photograph by Ryan Chamberlain.)

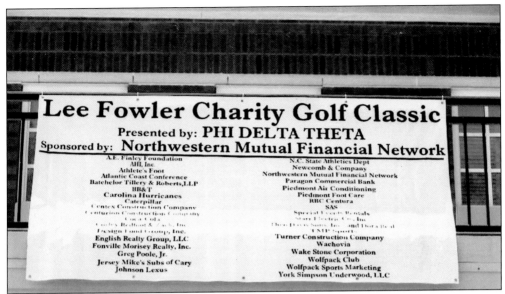

The Lee Fowler Charity Golf Classic is presented annually by Phi Delta Theta. Its proceeds benefit Lou Gehrig's disease. Fowler is the athletic director. The North Carolina State Athletics Department comes out in full force to support the efforts of the fraternity. (Photograph by Ryan Chamberlain.)

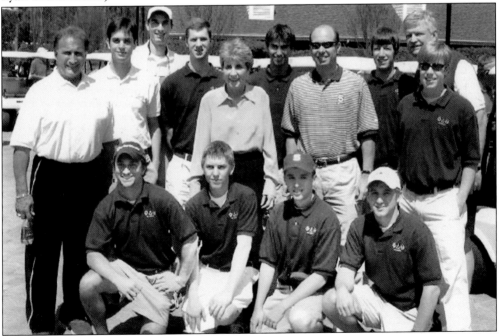

Members of Phi Delta Theta pose with members of the Athletics Department. They are, from left to right, as follows: (first row) John McKeever; Dan Thorn; Ryan Chamberlain; and Andrew Schmidt; (second row) Chuck Amato, North Carolina State head football coach; Burke Salsi Jr.; Travis Salyer; Nate Deiring; Kay Yow; women's basketball head coach; Mike Kimosh; Herb Sendek, men's head basketball coach; Patrick Cleary; Lee Fowler, athletic director; and Heath Spivey. (Courtesy of Phi Delta Theta.)

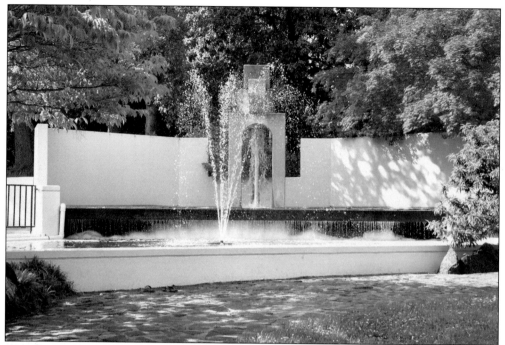

The fountain in front of the Talley Student Center furnishes a respite on a sunny day. The fountain, with its waterfalls and sculpture, is also a draw for wading students who wish to cool off on a hot day. (Photograph by Burke Salsi.)

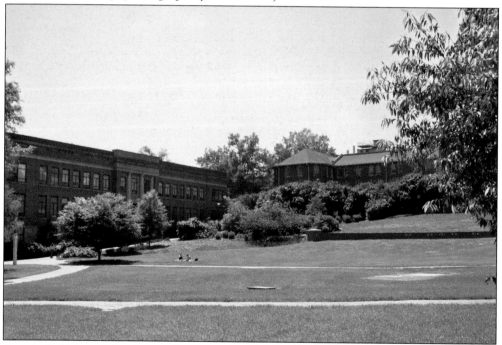

Co-eds (left) found the Court of North Carolina to be a sunny spot to study for finals. The Court is now a pleasant spot with a carpet of grass crisscrossed with walkways. It is unlike the late 1800s when it was a trampled field. (Photograph by Burke Salsi.)

James L. Oblinger took the oath of office as the 13th chancellor of North Carolina State in a ceremony in Reynolds Coliseum on Wednesday, April 20, 2005, before an audience of 3,000 people. (Courtesy of the Office of the Chancellor.)

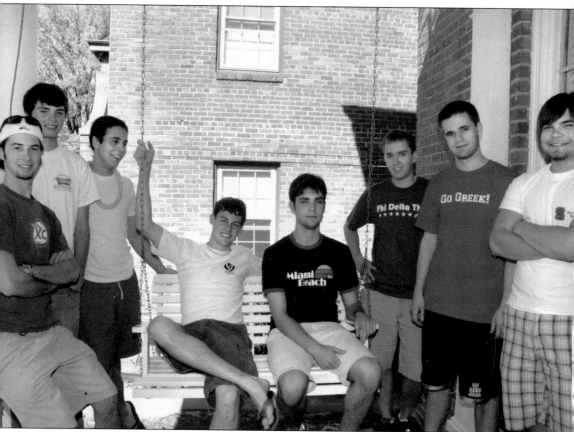

Phi Delta Theta brothers are hanging out on the porch on a spring day in 2005. They are, from left to right, David Jones, Nick Ward, Dale Meisenbach, David Myers, Burke Salsi Jr., Ryan Chamberlain, Brent Wilson, and Ashton Webb. (Photograph by Burke Salsi.)

ABOUT THE AUTHORS

Lynn Salsi is a historian, documentary writer, and children's book author. She was the recipient of the American Library Association Notable Book Award, is a six-time winner of the Willie Parker Peace History Book Award, and was named the North Carolina Historian of the Year by the North Carolina Society of Historians in 2001. She is a member of the Society of Children's Books Writers and Illustrators. Lynn is the author of 10 books, including 5 for Arcadia Publishing.

Burke A. Salsi Jr. ("Bo") is a student at North Carolina State University, where he is a member of Phi Delta Theta. This is his second book; he is the co-author of *Discover North Carolina from Murphy to Manteo*. He is a recipient of the Paul Green Multi-Media Award and a former member of the North Carolina Touring Theater.